ARTSPACE
WAS

ARTSPACE
IS

ARTSPACE WAS
WAS

YORK

NEW

a place in time

ARTSPACE IS

ARTSPACE BOOKS
NEW YORK

The story of Artspace is a simple one. On one level, it is about the desire and passion of one person to add to the dialogue of contemporary culture. On another, it is how this idea was embraced by so many talented artists, writers, students and a public to change a place in time. The idea became a reality in 1986 in San Francisco's South of Market area in a remodeled typewriter repair shop.

During the 15 years that have followed, Artspace has presented work in every medium, and given grants in support of painting, sculpture, video post production, and critical writing. We have published a magazine, 10 books, and helped filmmakers with their projects. When necessary, we have provided travel grants to artists for everything from photographing a music festival in Cartagena to a special grant for reuniting lovers. We have paid health care when needed, initiated an education IRA program for artists' kids and each Christmas operated The Toy Factory, a fund raiser where artists got together and made sculptures out of broken toys to benefit the Toys for Tots campaign. We transformed a restaurant on the corner of Ninth and Folsom and named it Limbo. It was a place where artists ate and drank and on every Wednesday night even cooked the specials. We had an advisory board that never met. We were never members of anything professional and for our own good reasons. Our fall from grace with the NEA wasn't by design on our part but by the nature of the original idea. We also had serious fun.

Whether you know what an education IRA is or not really doesn't matter. I want people to get the point that Artspace is a full service organization that attends to all the needs of artists as they come up. It is important for me to say that. We were a reaction to the art organizations that had stringent guidelines and never wavered from them when situations presented themselves that required help, if not in a formal sense, in a human sense. For this I take full responsibility but none of the credit. That belongs to so many other people who have worked so hard to make it happen.

There are a great many people to whom I owe a great debt for their tireless work on behalf of Artspace. Anyone who is involved in this kind of space knows that the hours are not 9 to 5 and that there is no job description for what we have to do each day to make it all work. Maureen Keefe is the perfect example. Not only did she do all of the administrative work to make things actually happen but was actively involved in many exhibitions, from locating thousands of magazines and a VW bug(hers) for David Mach's installation, to signing up as a cowgirl extra in *Beyond and Back*, a video movie. Maureen has always been a willing and enthusiastic participant, and I can't thank her enough.

John McCarron, our first curator, had such a profound influence that it is hard to believe that he was only with us for two years. His memory lives on in all the artists and friends to whom he gave so much. Kristin Johnson has made the most of every experience, working with artists and writers to design our books and magazine at a level so high she has set new standards and accomplished an unsurpassed body of work. To Kristin I will always be grateful.

To Richard Manoogian who always supported my work and to my son Jim who ran Limbo brilliantly and put up with all of our shenanigans, thank you so much. I want to give special thanks to Tony Labat, who helped shape the video and performance program through his passion as an artist and teacher and his generosity to me as a friend is something that I will always cherish. There are many others to thank. Bob Dix, Maura Nolan, Bruce Kremer, Izhar Patkin whose friendship and moral support carried me through many a crisis and to my friend Ed Leffingwell whose skill as a writer and editor saved me many an embarrassment. To Tony Korner, Amy Homes, Jim Lewis, Maria Theresa Caparotta, Carlo McCormick and Ingrid Sischy, thank you for your kindness. I am grateful to Amy Scholder for her help with the book series. And thanks to the co-editor of The Snitch, you know who you are. Last but not least I owe so much to my daughter Bridget and to my angel Michael whose love and a cup of tea got me through it all.

Artspace is now in New York City with all the promise that a new space and new ideas bring. We also bring with us all of those things that worked in San Francisco and all of the good intentions on which Artspace was founded. We have added DV editing into our program and will expand our book publishing to go beyond the collaboration series represented in this book, and then we'll sit back and see where we can help, what we can do for artists and what kind of trouble we can get into here.

Anne MacDonald

This book is dedicated to the memory of Sam Wagstaff. I was lucky enough to meet that special person when I was young who changed my life forever. Sam taught me through his example about the possibilities of participating in a meaningful way with the artists of our time. I never would have been able to even dream Artspace without him.

ARTSPACE WAS ABOUT ideas

ARTSPACE WAS ABOUT art

Artspace Opening

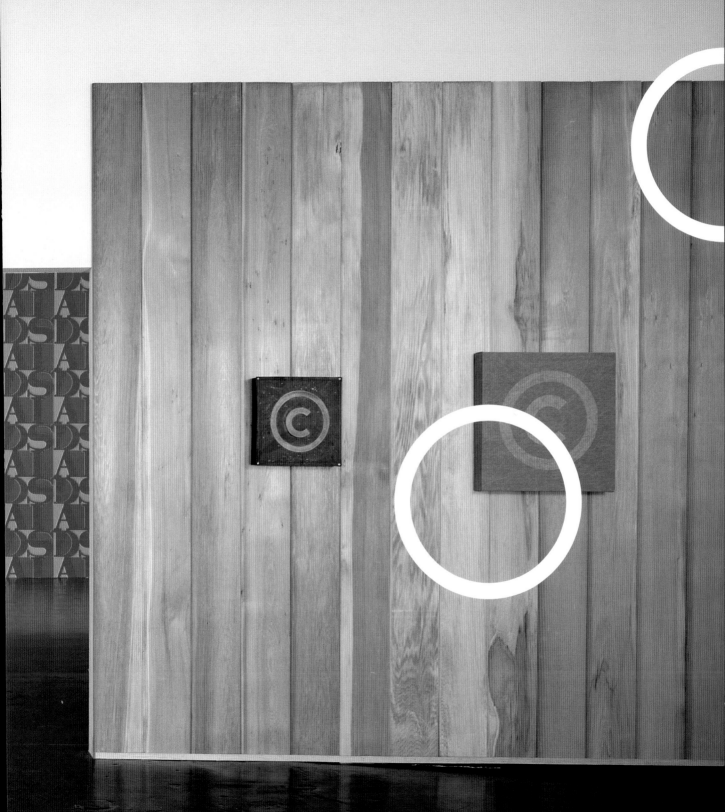

General Idea *The Public and Private Domains of The Miss General Idea Pavilion*

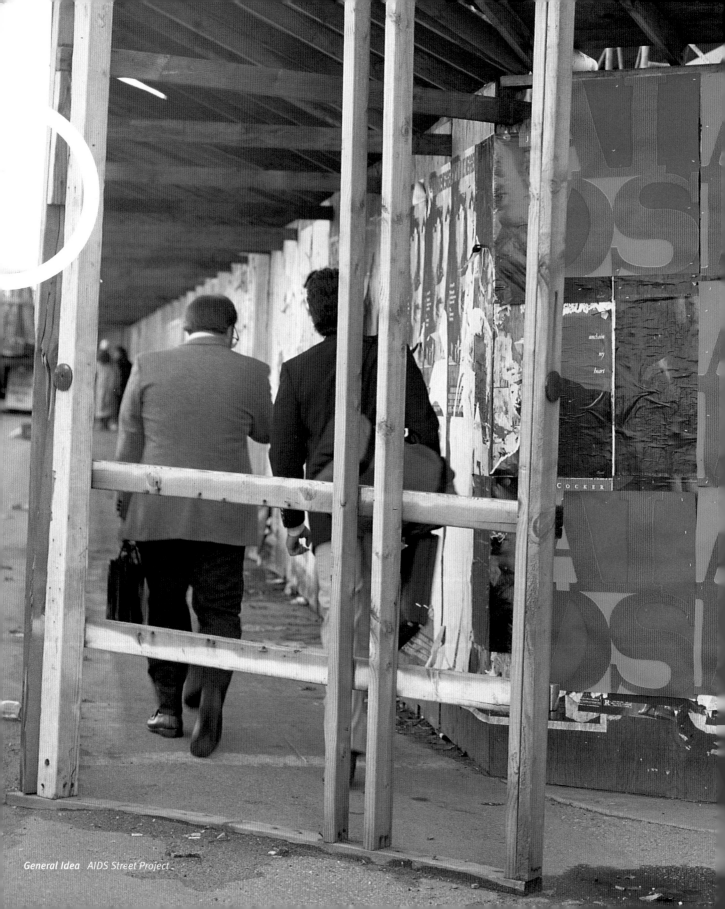

General Idea AIDS Street Project

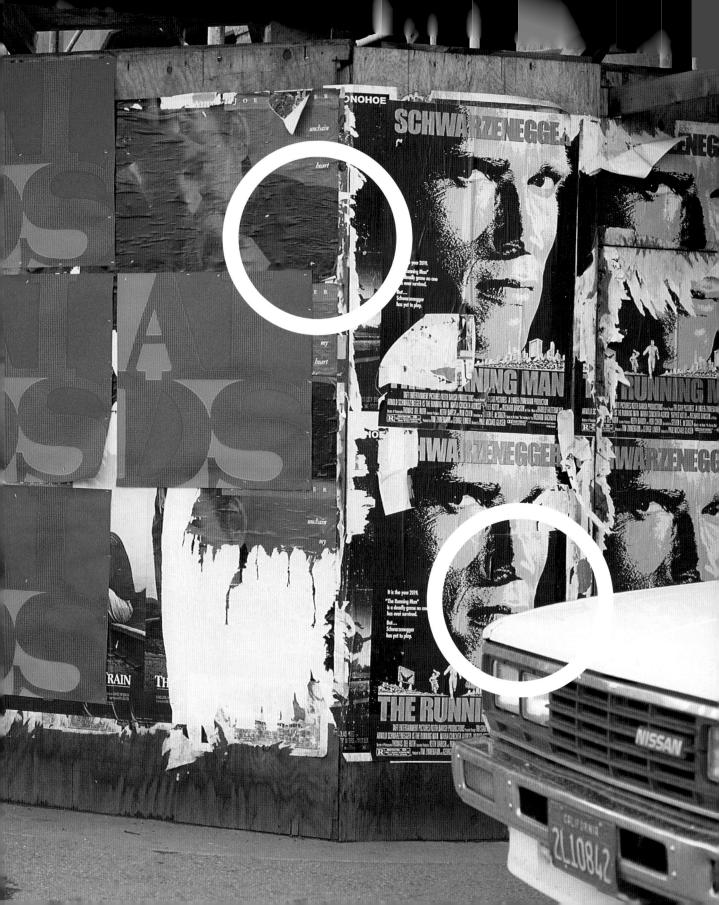

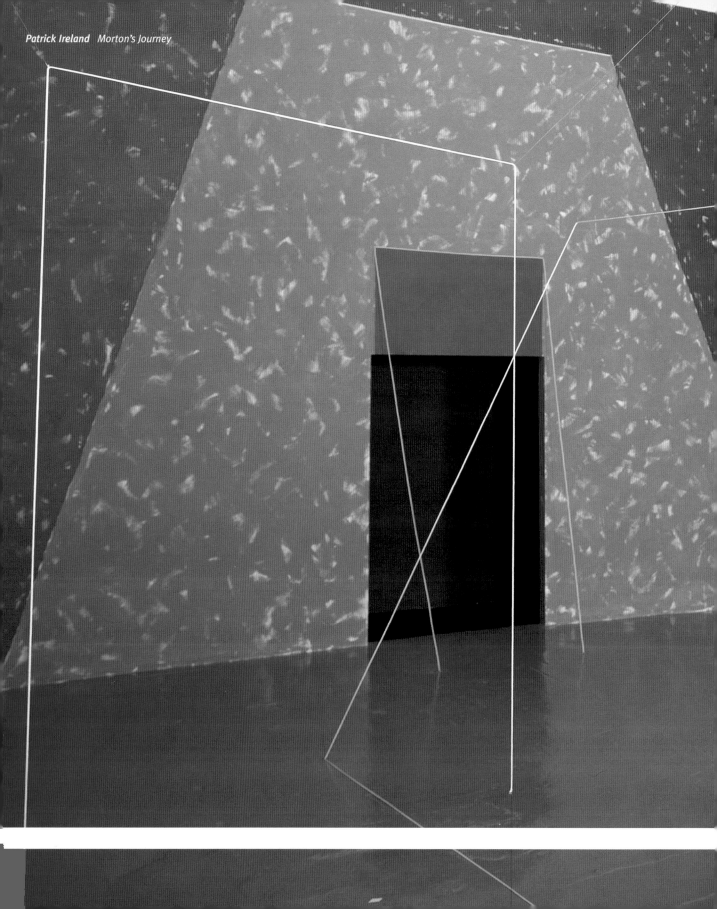

Patrick Ireland Morton's Journey

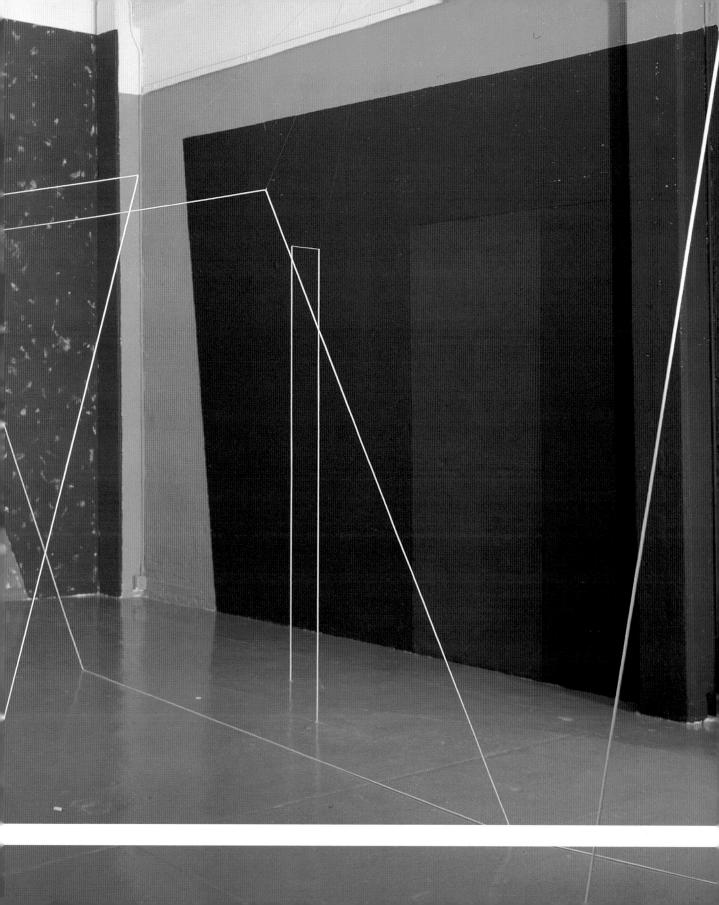

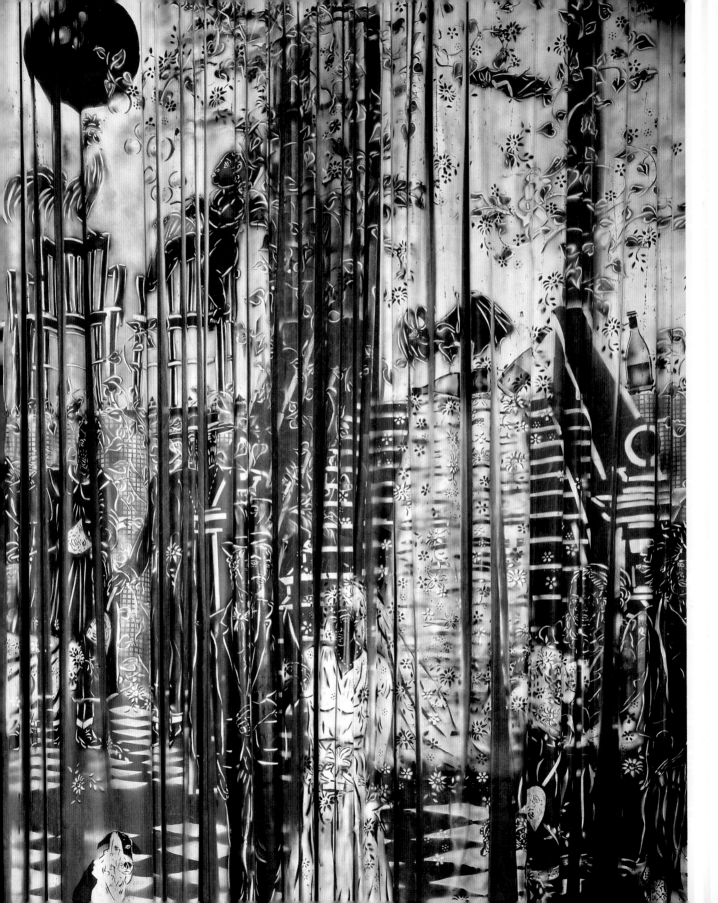

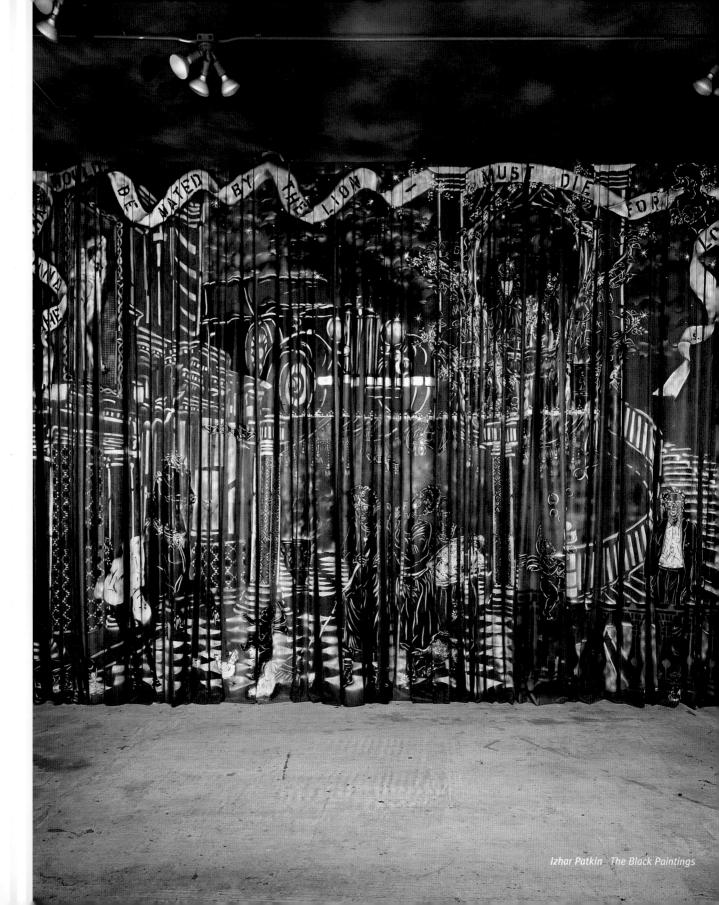

Izhar Patkin The Black Paintings

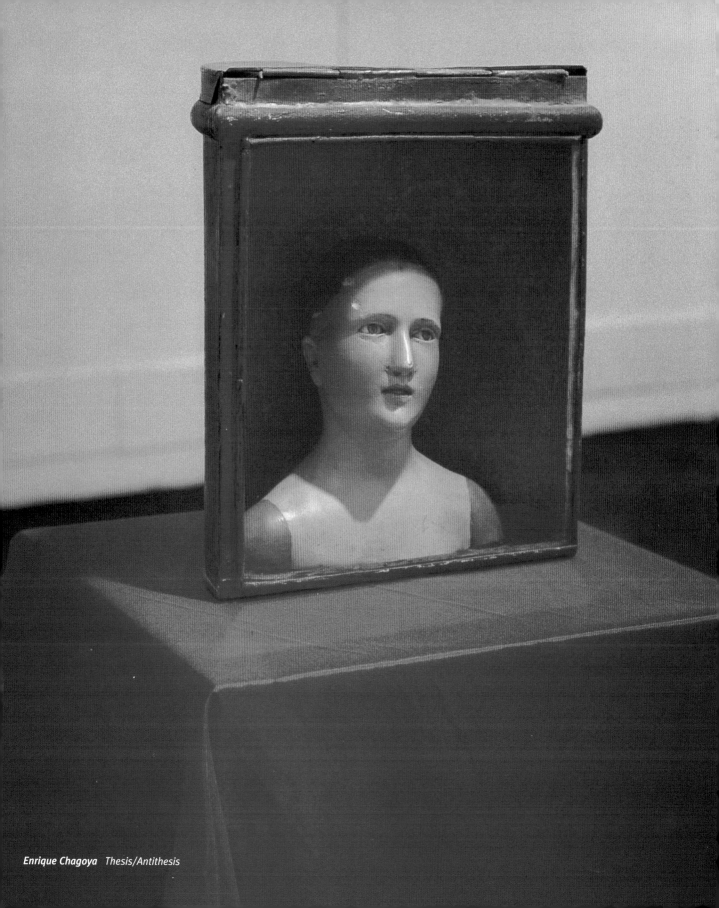

Enrique Chagoya *Thesis/Antithesis*

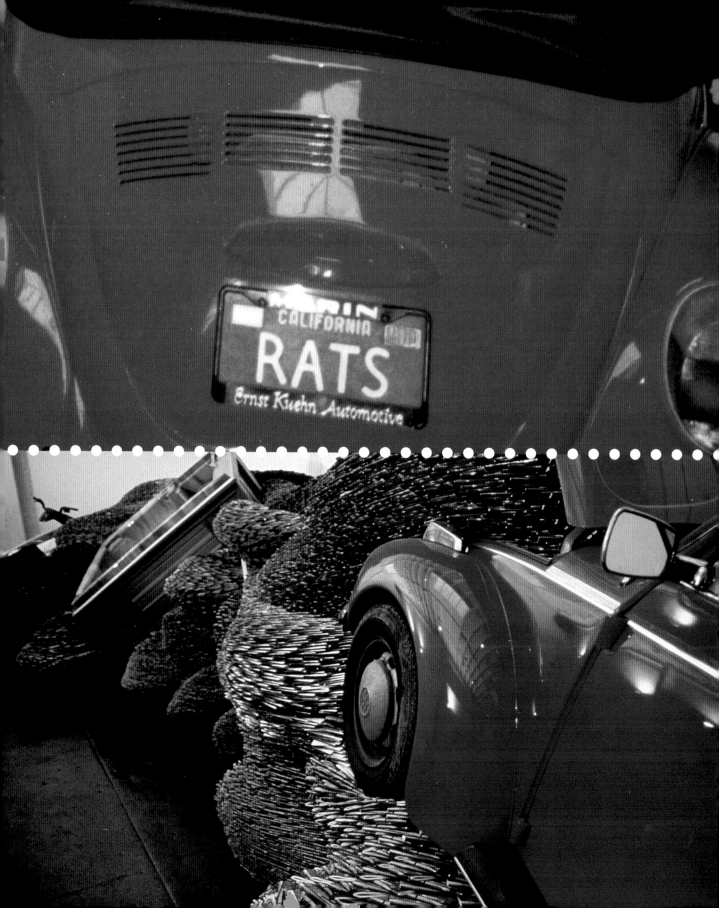

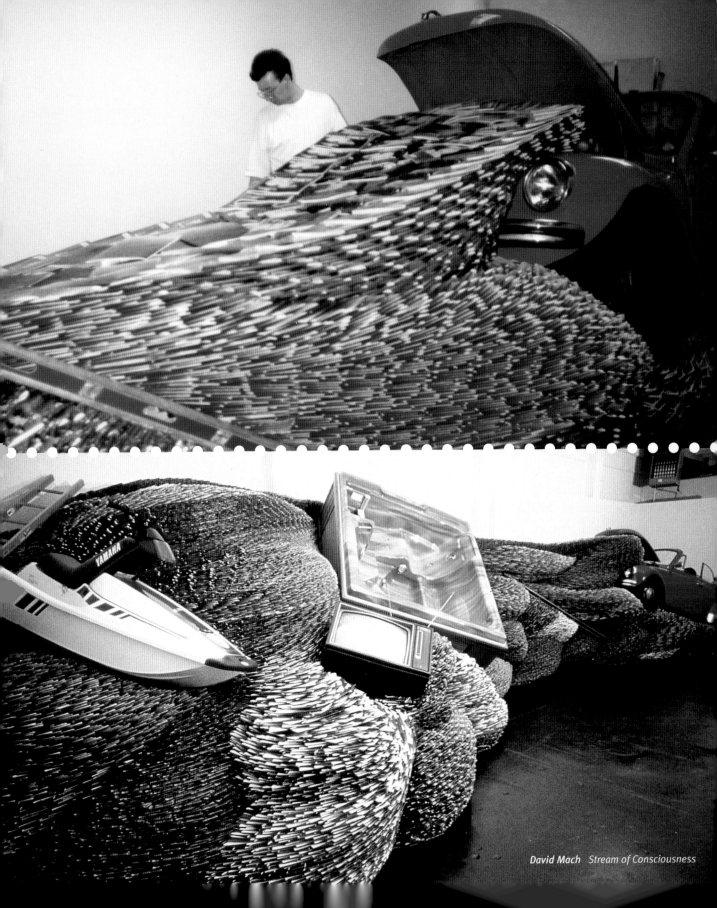

David Mach *Stream of Consciousness*

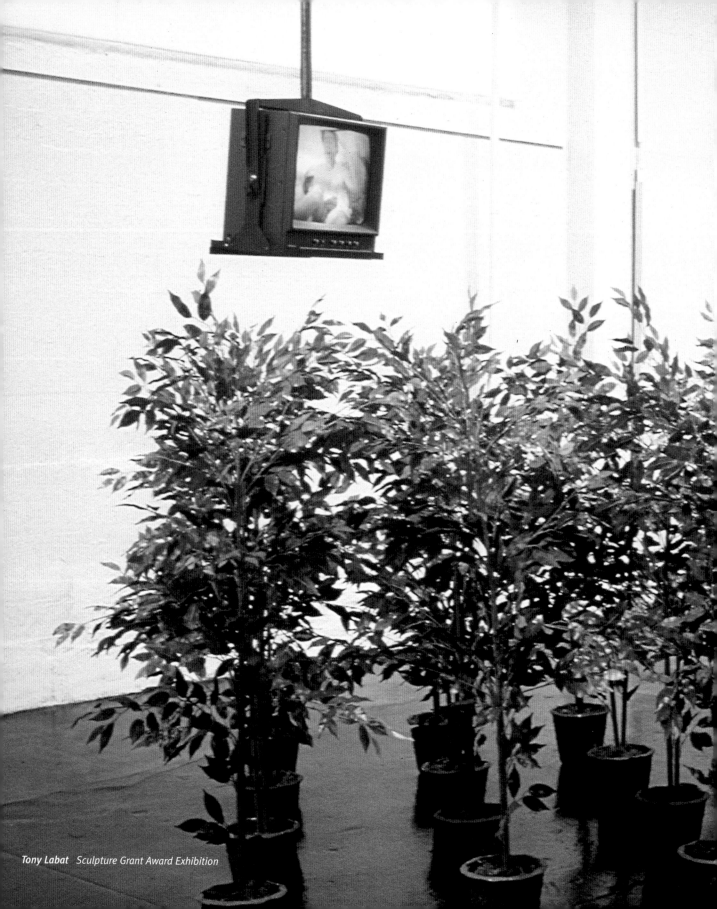

Tony Labat *Sculpture Grant Award Exhibition*

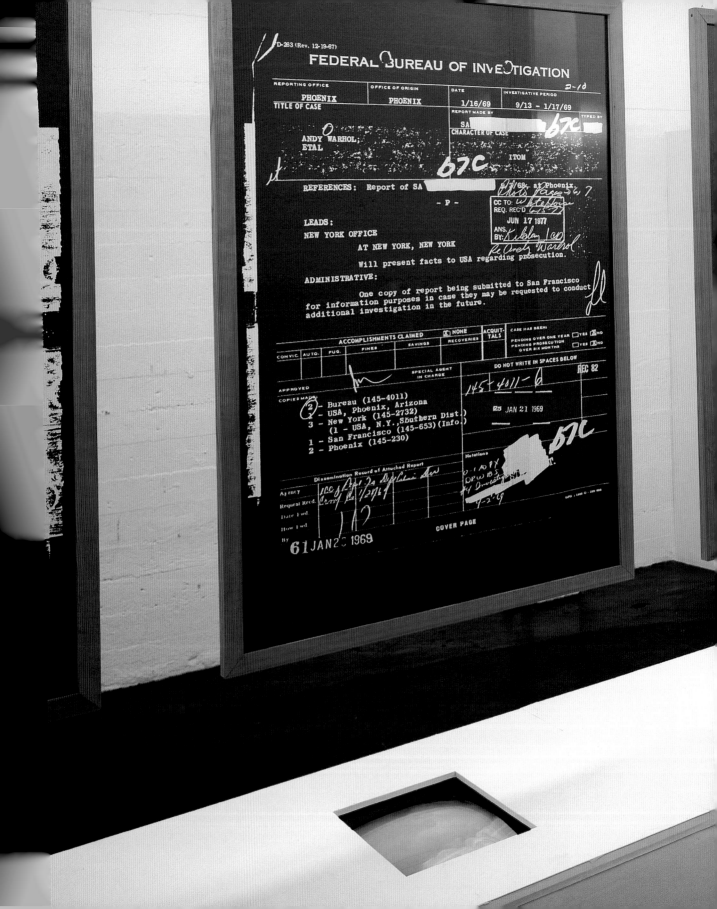

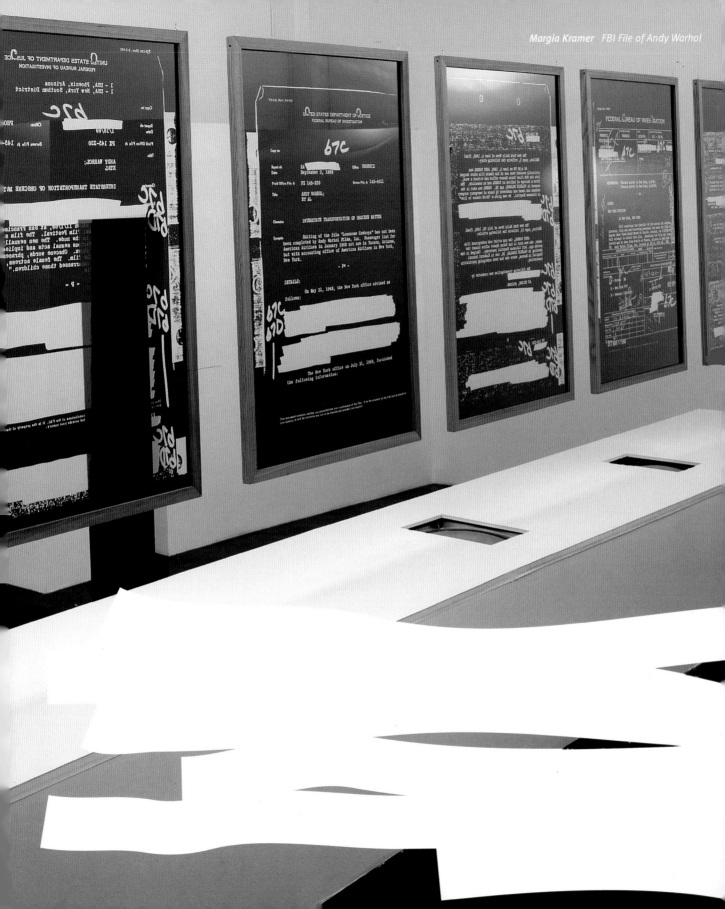

FEDERAL BUREAU OF INVESTIGATION

2-10

REPORTING OFFICE	OFFICE OF ORIGIN	DATE	INVESTIGATIVE PERIOD
PHOENIX	PHOENIX	1/16/69	9/13 - 1/17/69

TITLE OF CASE	REPORT MADE BY	TYPED BY
ANDY WARHOL; ETAL	SA **b7C**	

CHARACTER OF CASE

b7C

ITOM

REFERENCES: Report of SA 8/3/68 at Phoenix.

Photo Pages 5, 6, 7

- P -

CC TO: White House
REQ. REC'D 6/15/77
JUN 17 1977
ANS.
BY: Kublay / CD

Re Andy Warhol

LEADS:

NEW YORK OFFICE

 AT NEW YORK, NEW YORK

 Will present facts to USA regarding prosecution.

ADMINISTRATIVE:

 One copy of report being submitted to San Francisco for information purposes in case they may be requested to conduct additional investigation in the future.

	ACCOMPLISHMENTS CLAIMED				☒ NONE	ACQUIT-TALS	CASE HAS BEEN:		
CONVIC.	AUTO.	FUG.	FINES	SAVINGS	RECOVERIES				

CASE HAS BEEN:
PENDING OVER ONE YEAR ☐ YES ☒ NO
PENDING PROSECUTION OVER SIX MONTHS ☐ YES ☒ NO

APPROVED _____ SPECIAL AGENT IN CHARGE

COPIES MADE:

- ②- Bureau (145-4011)
- 1 - USA, Phoenix, Arizona
- 3 - New York (145-2732)
- (1 - USA, N.Y., Southern Dist.)
- 1 - San Francisco (145-653)(Info.)
- 2 - Phoenix (145-230)

DO NOT WRITE IN SPACES BELOW

145-4011-6

REC 82

25 JAN 21 1969

b7C

Dissemination Record of Attached Report			Notations
Agency			
Request Recd.			
Date Fwd.			
How Fwd.			
By			

61 JAN 20 1969

GPO : 1968 O - 298-895

JUN 23 1977

ANDY WARHOL FEDERAL GOVERNMENT

Captioned individual, who you advised is affiliated
with A. Warhol Enterprises, 860 Broadway, New York, New York,
may be identical with one Andy Warhol, identified in "Who's
Who in America (1972-1973)," as born August 8, 1931, Cleveland
(Ohio), and being an "artist, director, producer, photographer..
of movie 'Lonesome Cowboys, 1969'." His address was given as
"care Castelli Gallery, 4 East 77th Street, New York City," N.Y

SUMMARY

Warhol and others were the subjects of an interstate
transportation of obscene matter investigation conducted
by the FBI in 1968 and 1969 concerning the making of the
movie "Lonesome Cowboys" in part at Oracle, Arizona, by Andy
Warhol Films, Incorporated. Warhol was director and
camera man during the filming on January 24, 1968, at a
guest ranch wherein the naked female actress, "Viva"

Editing of the movie was delayed by the June 3, 1968,
shooting of Warhol by one of his female film stars who
barged into his New York office to inflict wounds in the
abdomen and chest requiring over five hours of surgery.
Warhol, described as a "pop artist and underground film maker,"
spent two months in a hospital before recovering.

REC-128 DE-9 145-4011 - 10

The motion picture "Lonesome Cowboys" was viewed by
two Special Agents of the FBI on November 1, 1968, at
San Francisco, California, and their review of the film is
attached herewith. (145-4011-6 pp 5,6,7) 2 JUN 28 1977

Federal injunction at Atlanta enjoined the local officials
not to further show the film to anyone. The "X" rated
movie suggested no one under age 18 to view the film.
Subsequently, by September, 1969, United States Attorneys
in New York City; Atlanta, Georgia; and Phoenix, Arizona, had
declined prosecution because the movie was not "obscene
within the definition of that word as defined by the Supreme
Court of the United States." (145-4011)

ELVIS ALIVE

COMMEMORATIVE
GOLD BAR / CHOCOLATE
CANDY BAR

COFFEE

ACHIEVERS

NO INSIDE, N
NO JOB WE

RADON CONTAMINATED HOMES. SLOPPY LABS MISLEAD
DIOXIN TAINTED TOILET PAPER. TRY DOING WIT
HORMONE-TREATED MEAT SUSPECTED CAUSE OF PRE
CHILDREN AS YOUNG AS 4.
INEPT CAPTAIN OF OIL TANKER SLIPS UP, CAUSIN
OF U.S.. EXXON SENDS 400 WORKERS TO CL
MOST BOEING 747 JETS CARRY USED URANIUM (950
FACILITIES IN THEIR TAILS AS COUNTER WEIG
WHAT OZONE LAYER? ANY TAN NOW CONSIDEREL
OVERWORKED LAB TECHNICIANS FALSELY AN
NOT EVEN THE RICH AND FAMOUS ARE SAFE: WAR
INATTENTIVE AT THE WRONG TIME. RESULT.
LYME DISEASE.
HOSPITAL WASTE BEACH.
Just the M

IN THE SALT?

America's Favorite

DELICIOUS
CHEESEBURGER
FOOD FOR THOUGHT

CABLE T.V.
DESCRAMBLERS

RETIN-A

KAHLUA

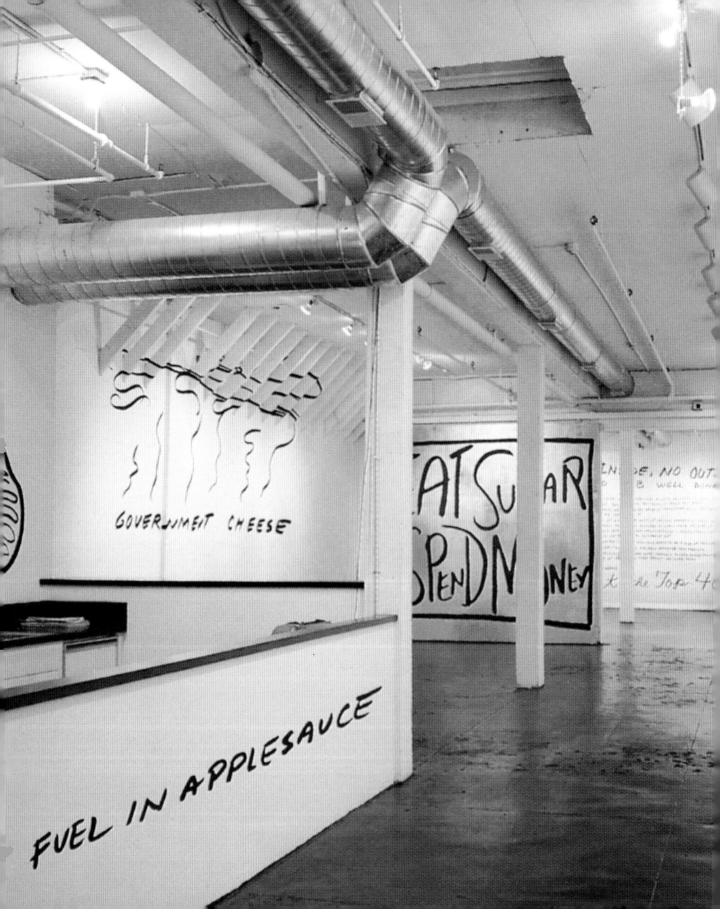

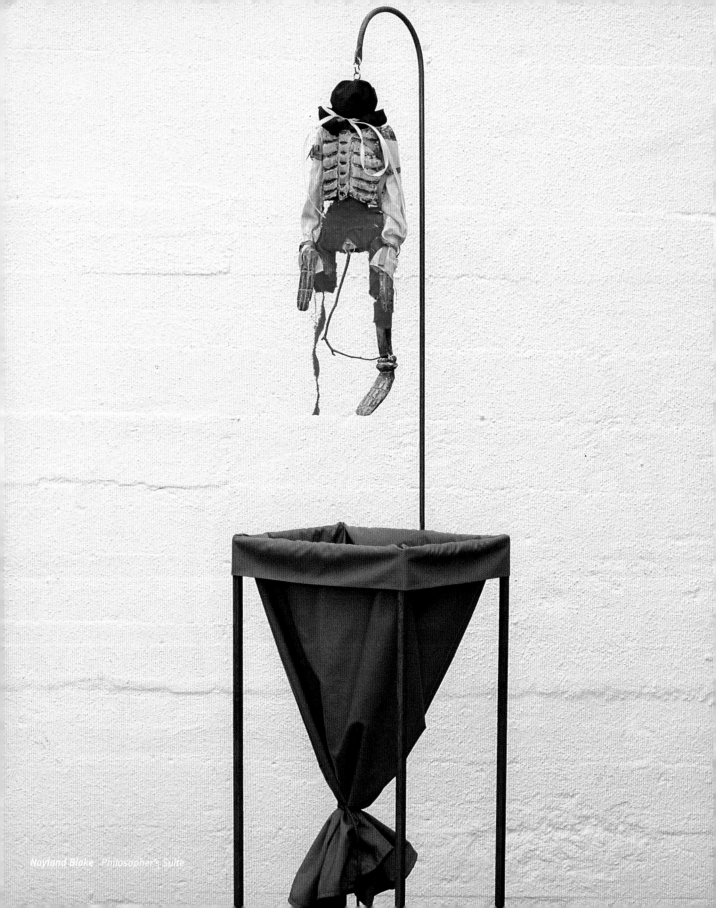

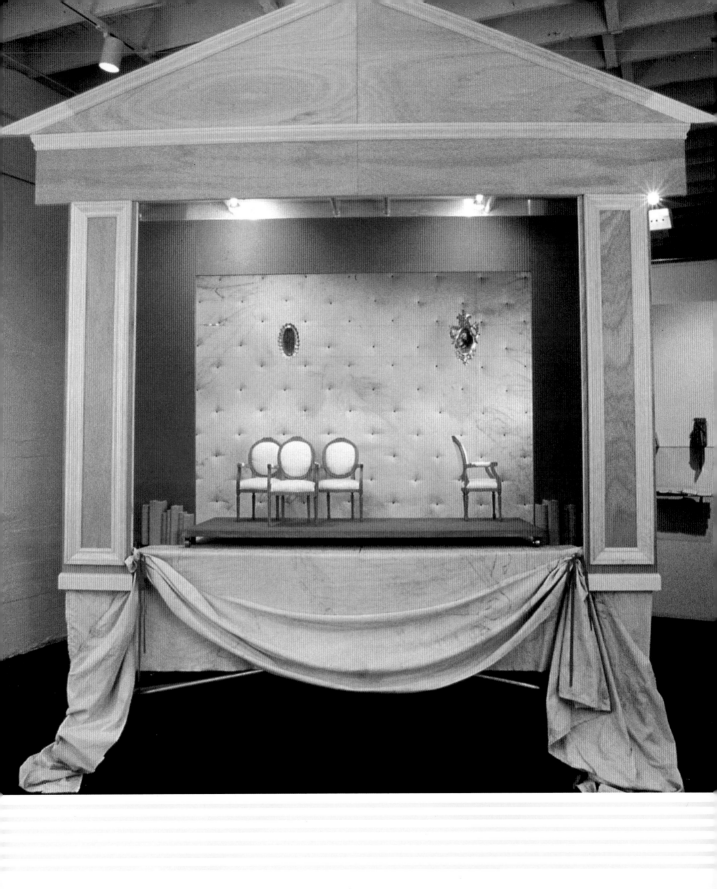

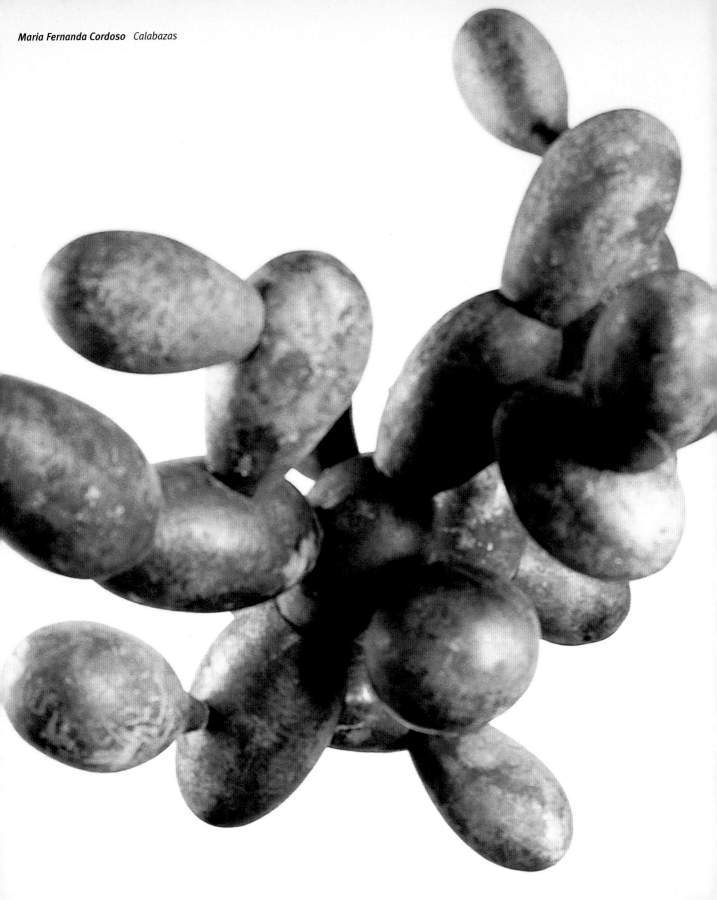

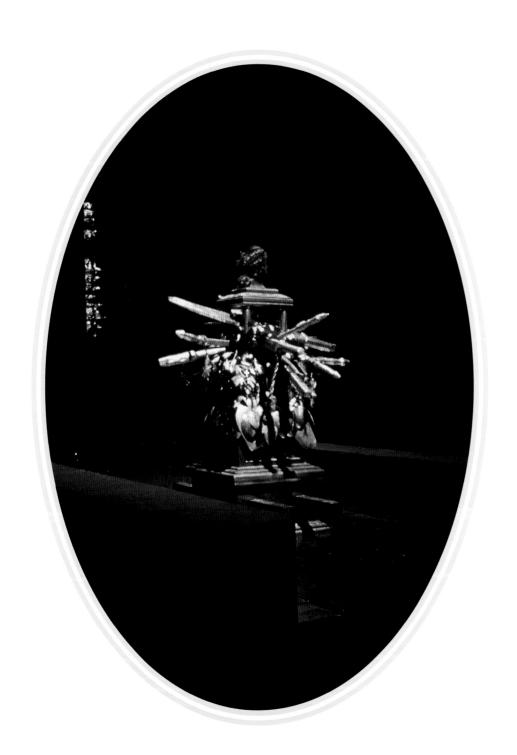

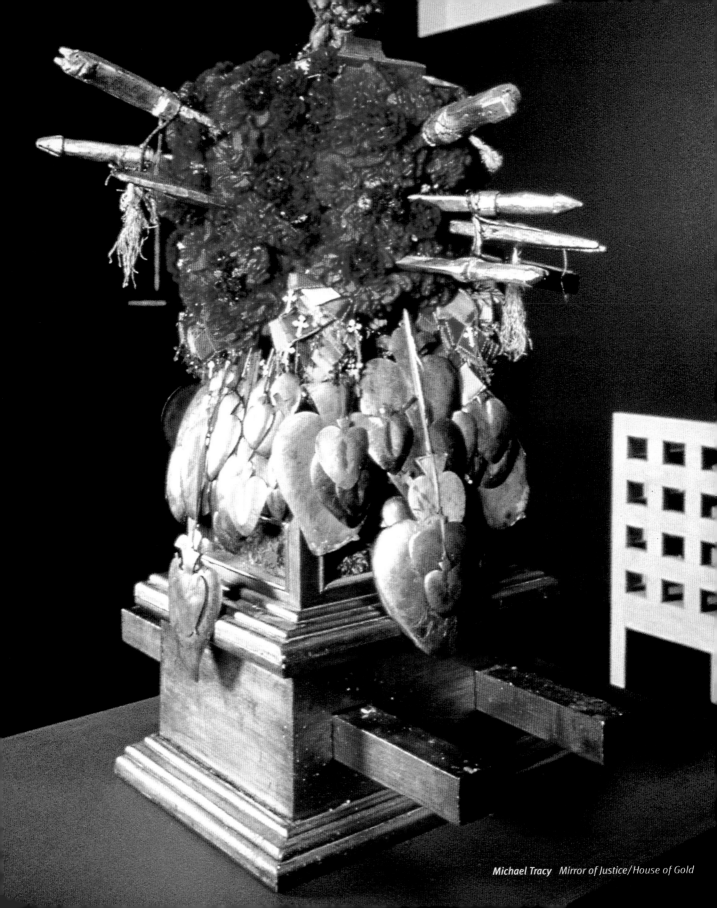

Michael Tracy Mirror of Justice/House of Gold

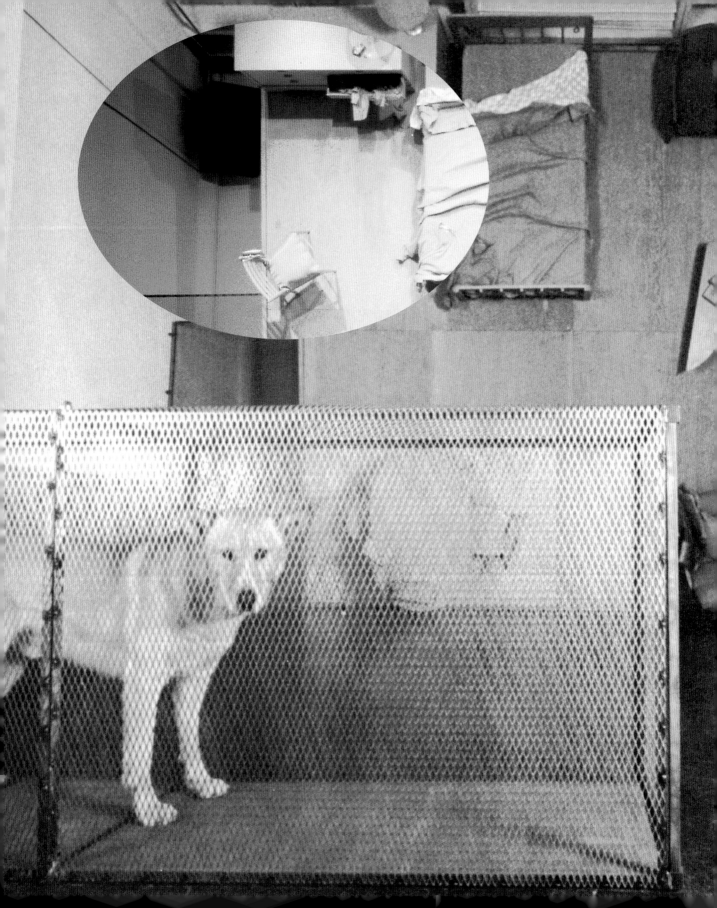

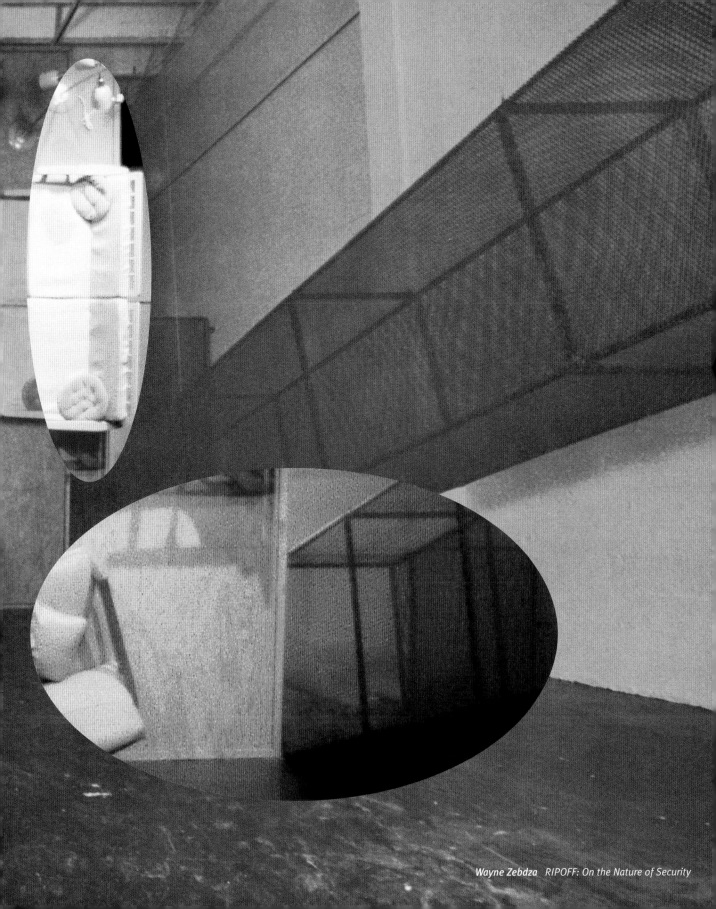

Wayne Zebdza RIPOFF: On the Nature of Security

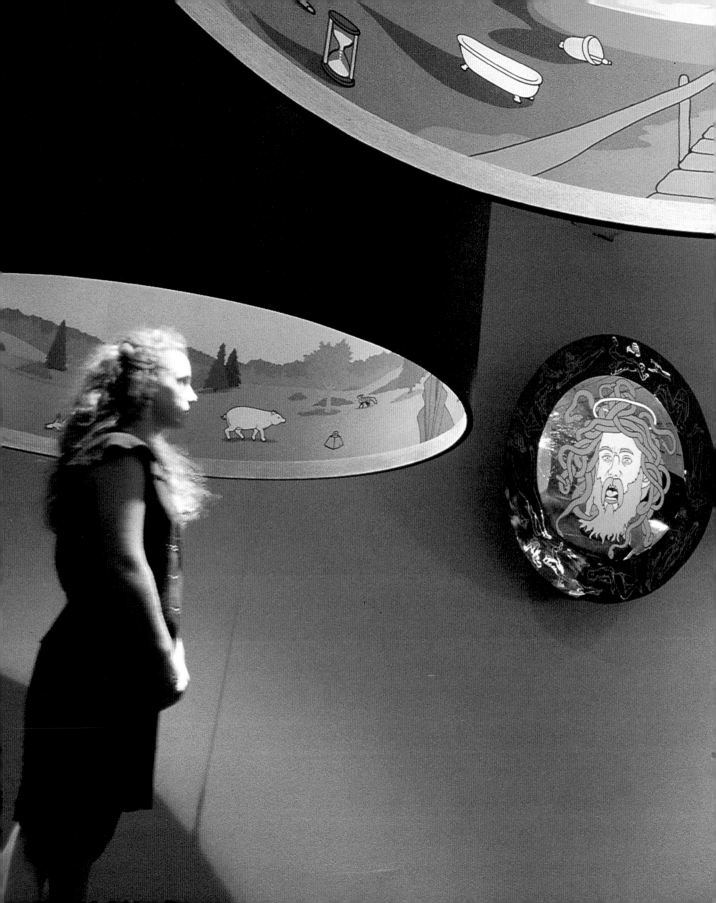

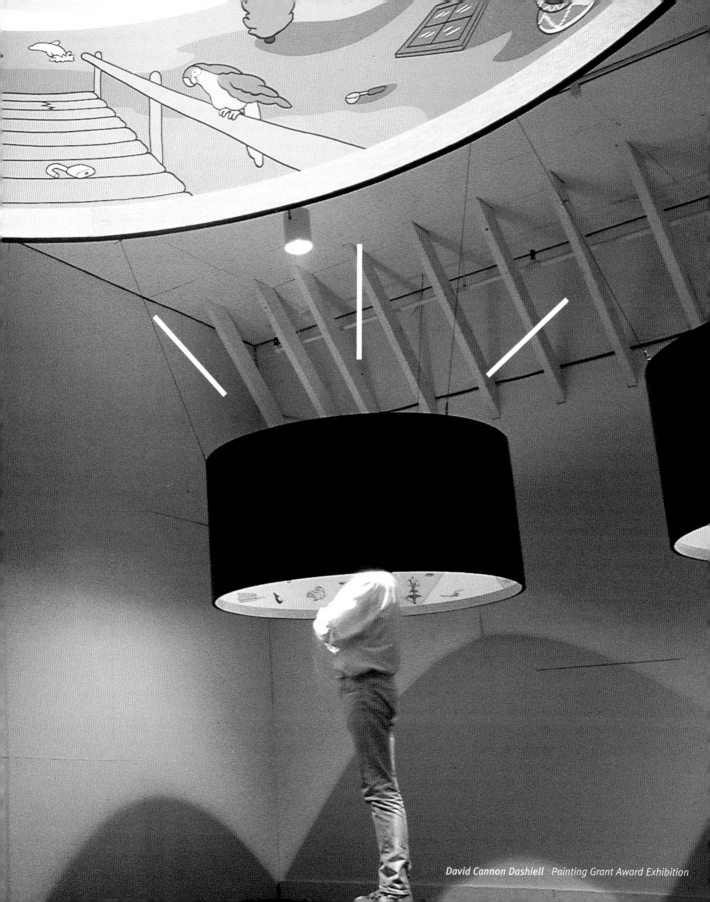

David Cannon Dashiell *Painting Grant Award Exhibition*

ARTSPACE WAS ABOUT process

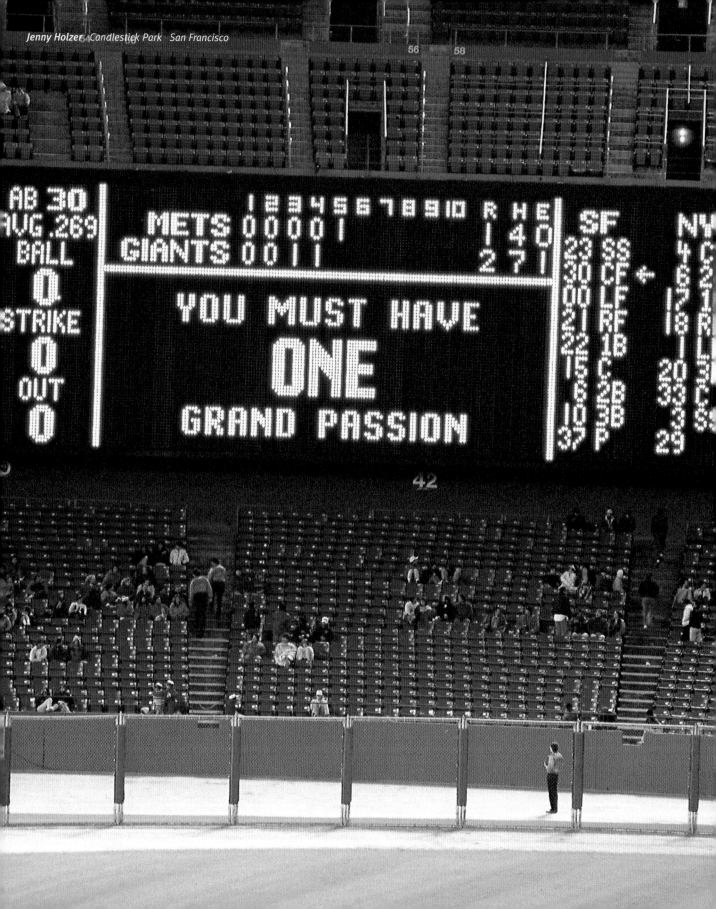

Jenny Holzer *Candlestick Park San Francisco*

TURN SOFT & LOVELY ANYTIME YOU HAVE A CHANCE

Jenny Holzer Design Center San Francisco

Mark Pauline

San Francisco Police Department

San Francisco Police Department

San Francisco Fire Department

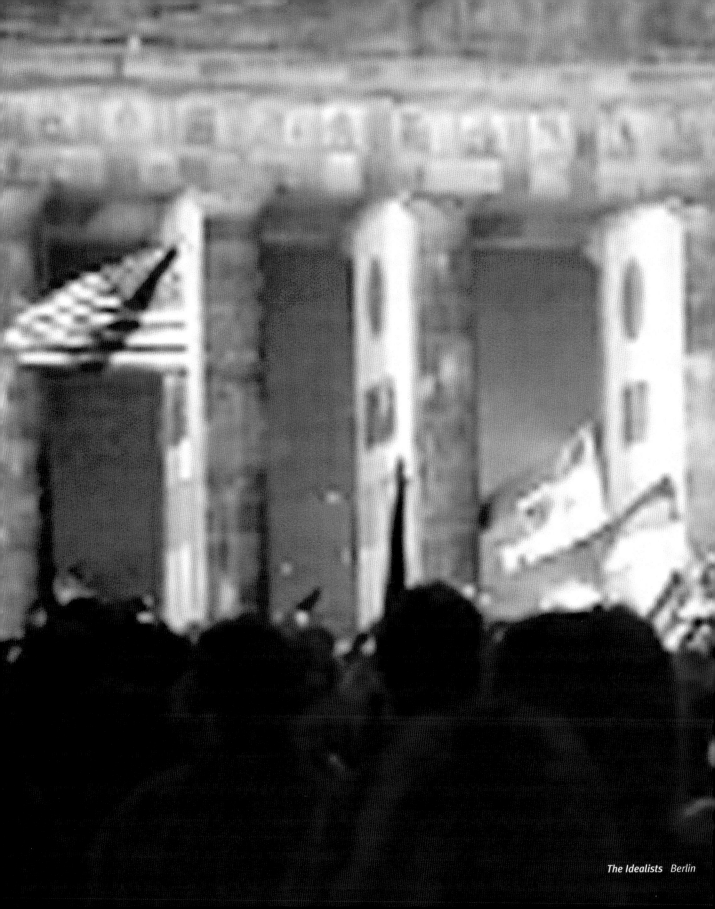

The Idealists Berlin

ARTSPACE WAS ABOUT performance

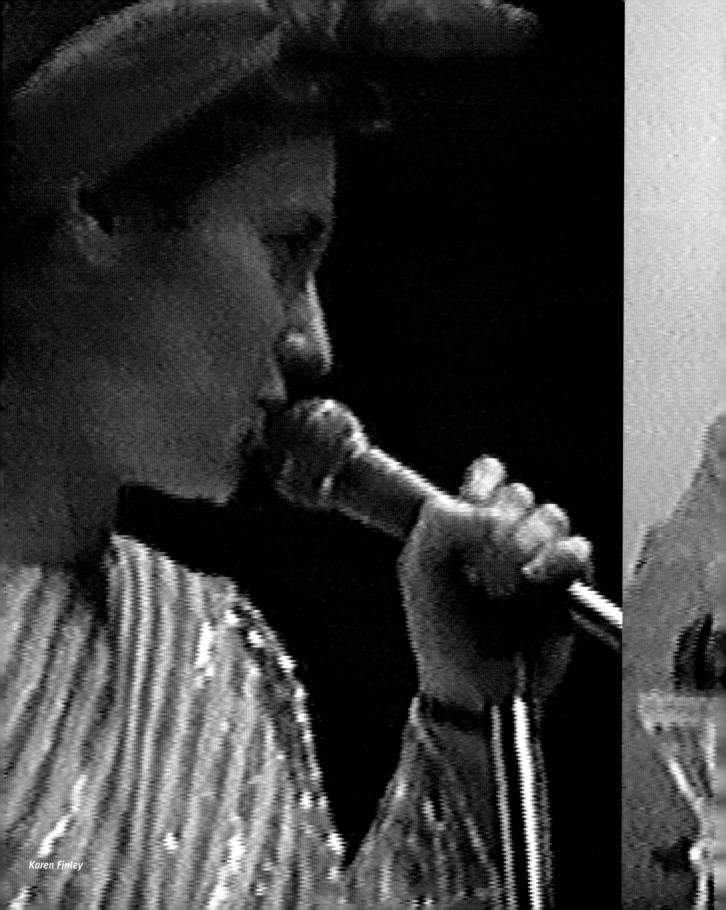

Karen Finley

Howard Fried

San Francisco Art

in collaboration w

the Goethe - Ins

presents

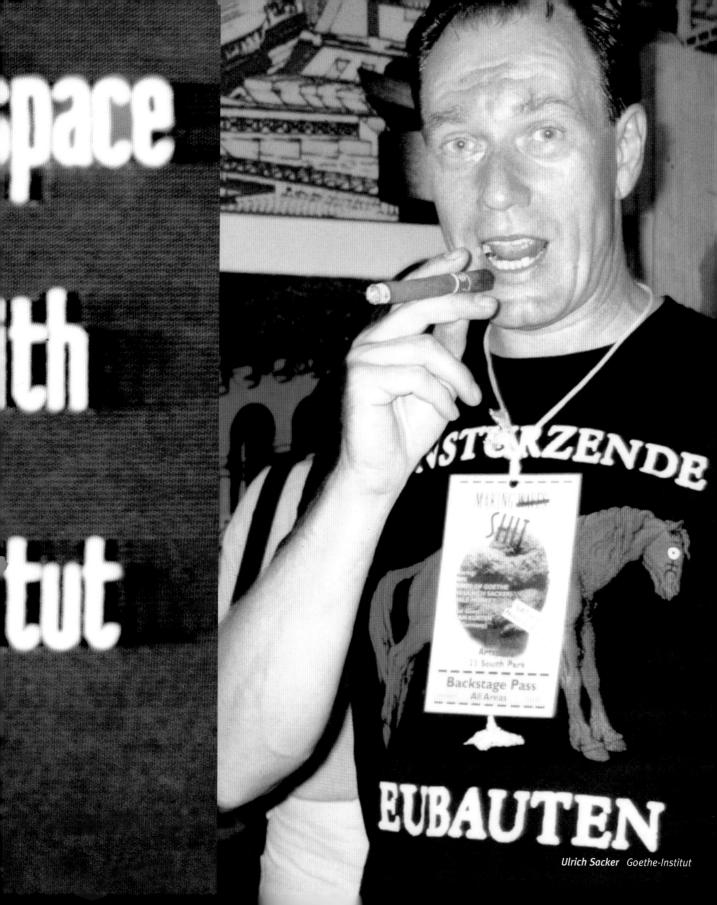

Ulrich Sacker *Goethe-Institut*

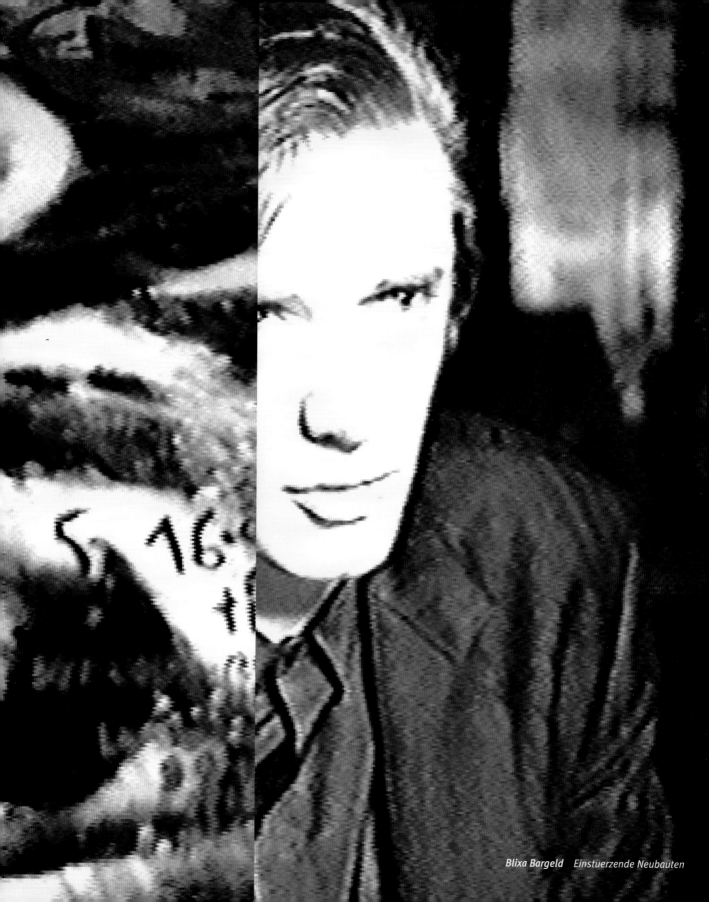

Blixa Bargeld Einstuerzende Neubauten

The Brain Brothers

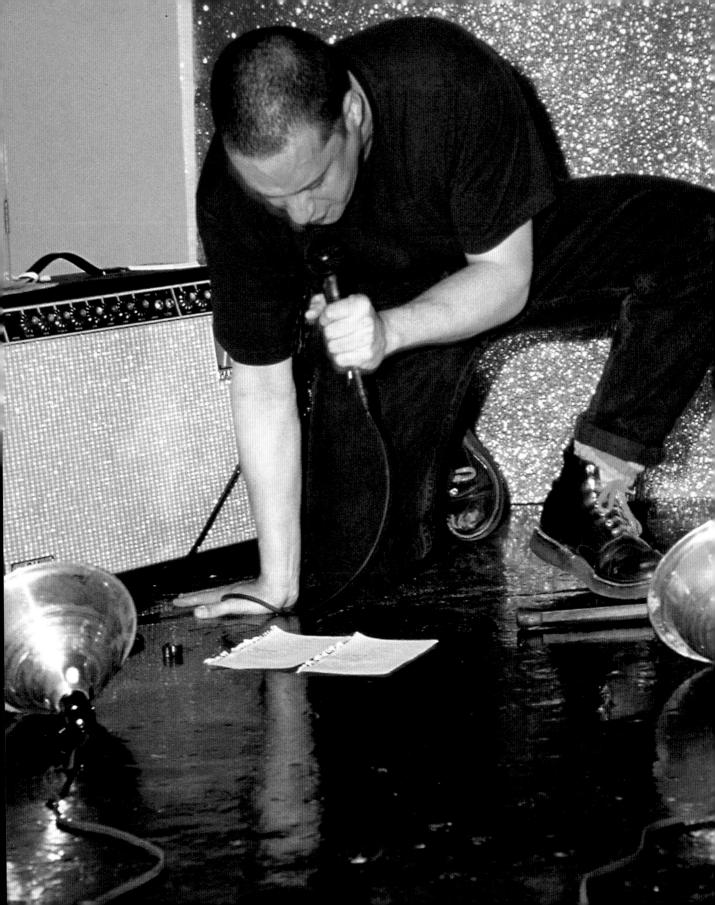

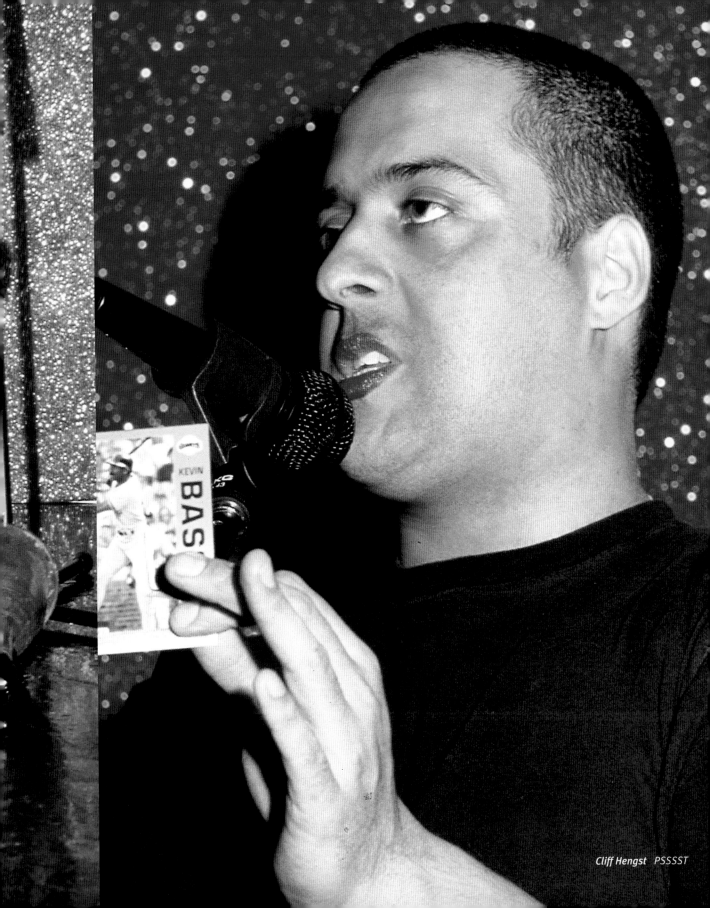

Cliff Hengst PSSSST

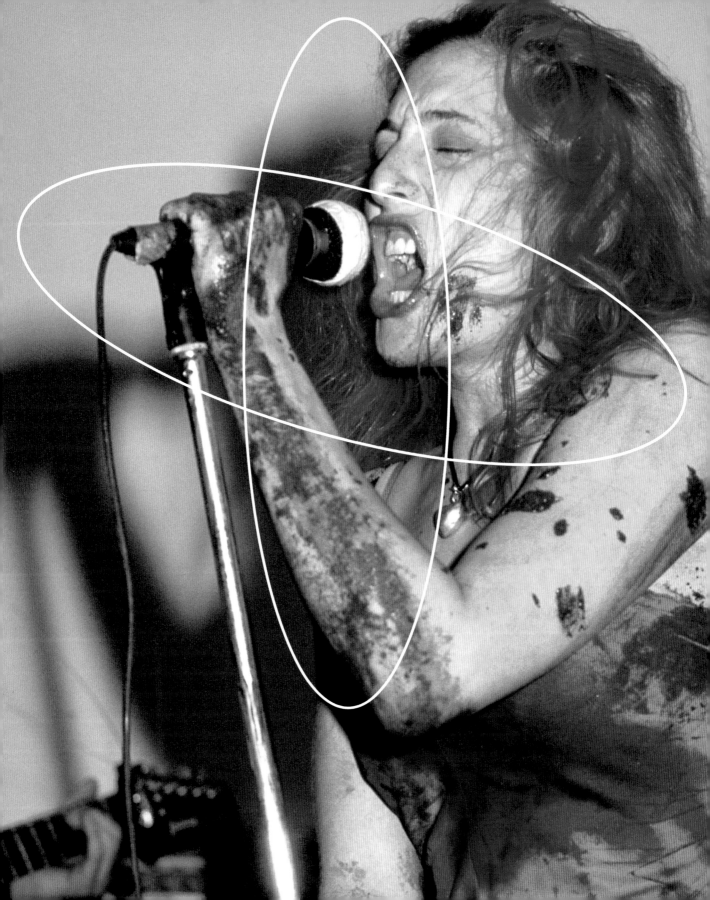

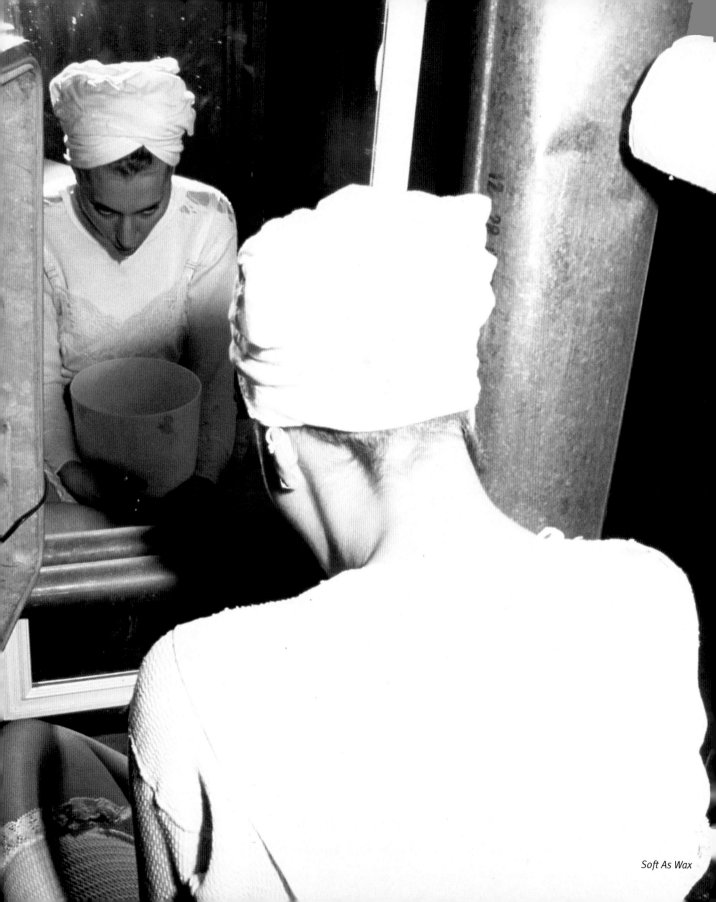

Soft As Wax

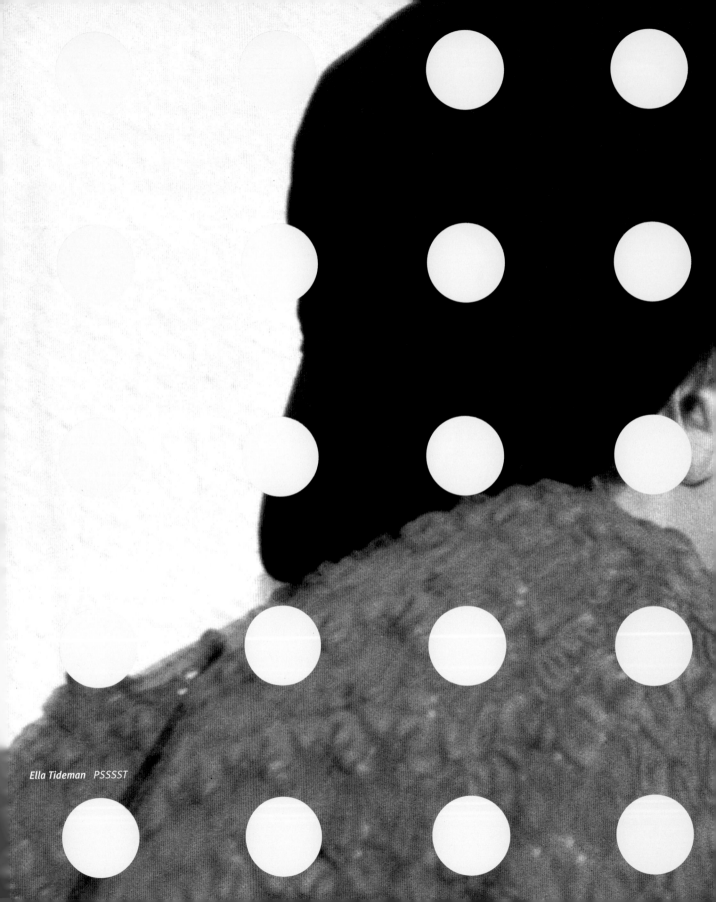

Ella Tideman PSSSST

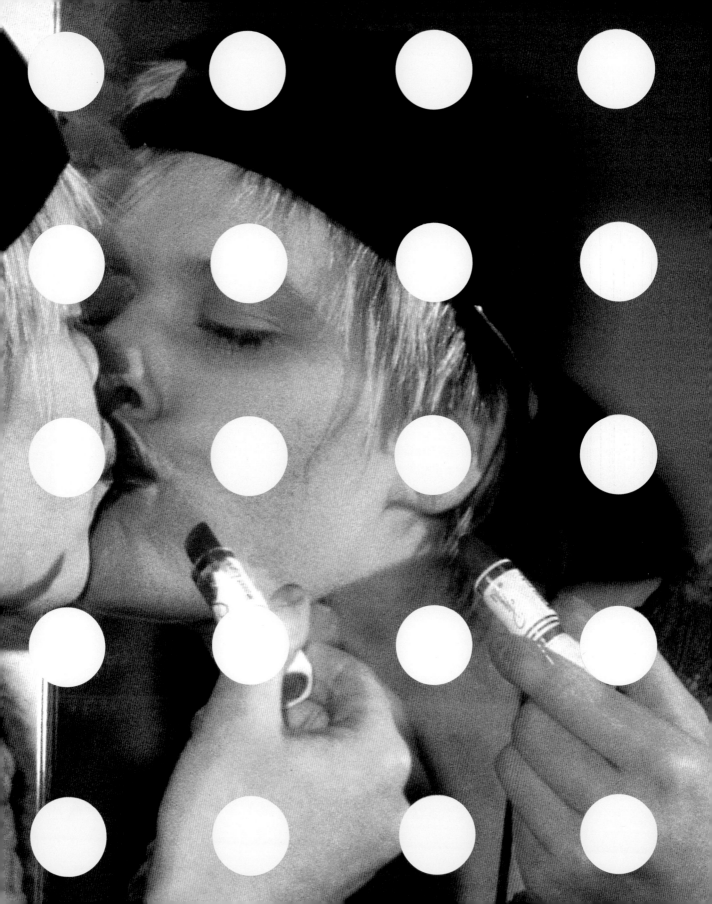

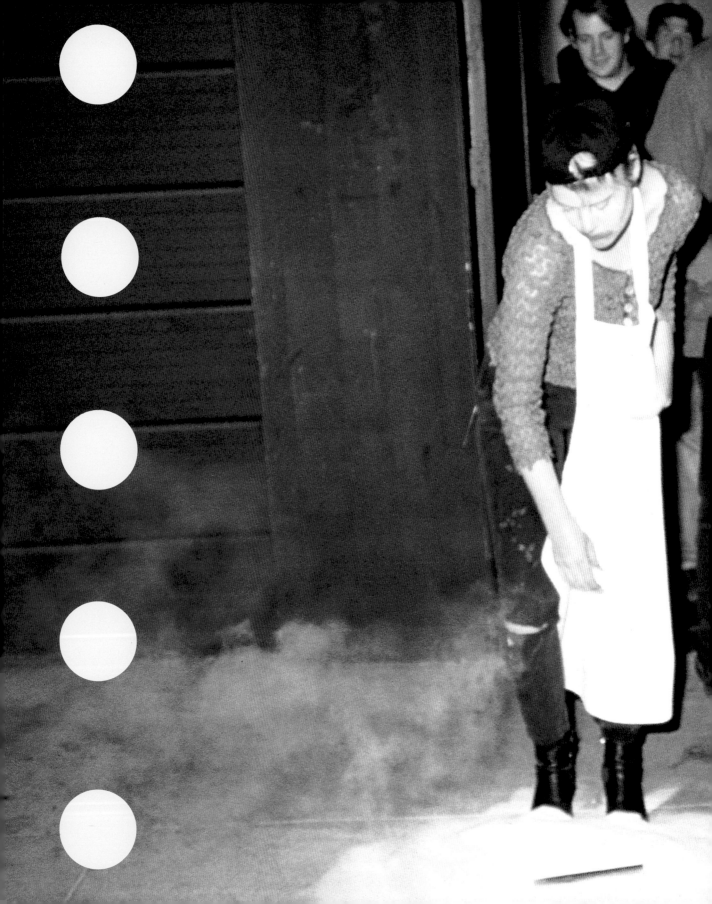

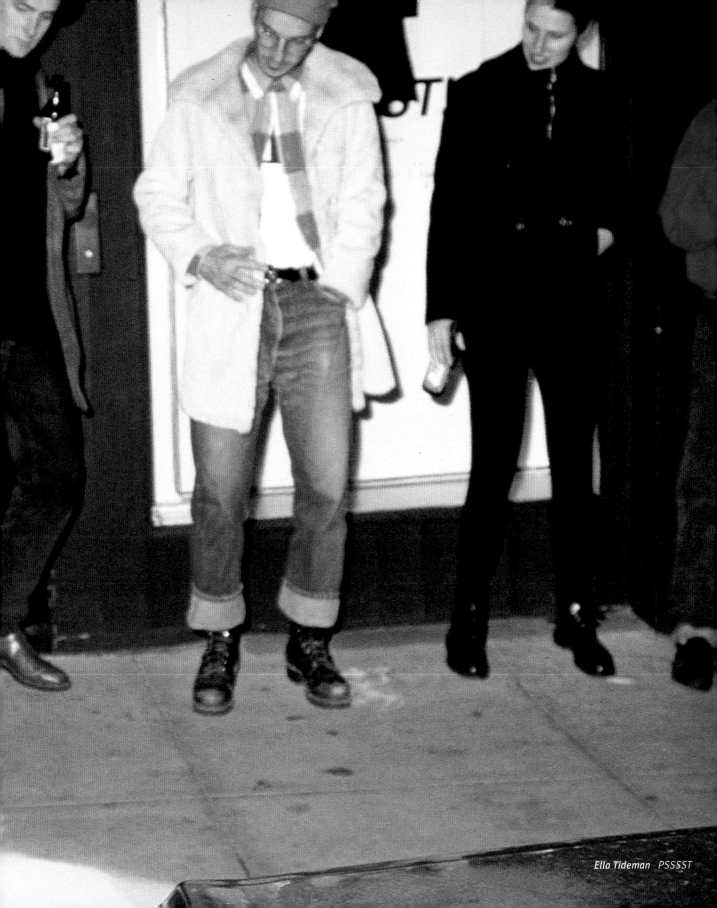

Ella Tideman PSSSST

ARTSPACE WAS ABOUT video

Stefan Kürten Then

Tony Oursler and Joe Gibbons Toxic/Detox

Toxic/Detox

was the most erotic

had with a woman.

Sophie Calle and Greg Shepard Double Blind

PM 4:43:10

Double Blind

Tony Ramos *Mao Meets Muddy*

Tony Labat *Locomotion*

ARTSPACE WAS ABOUT appetite

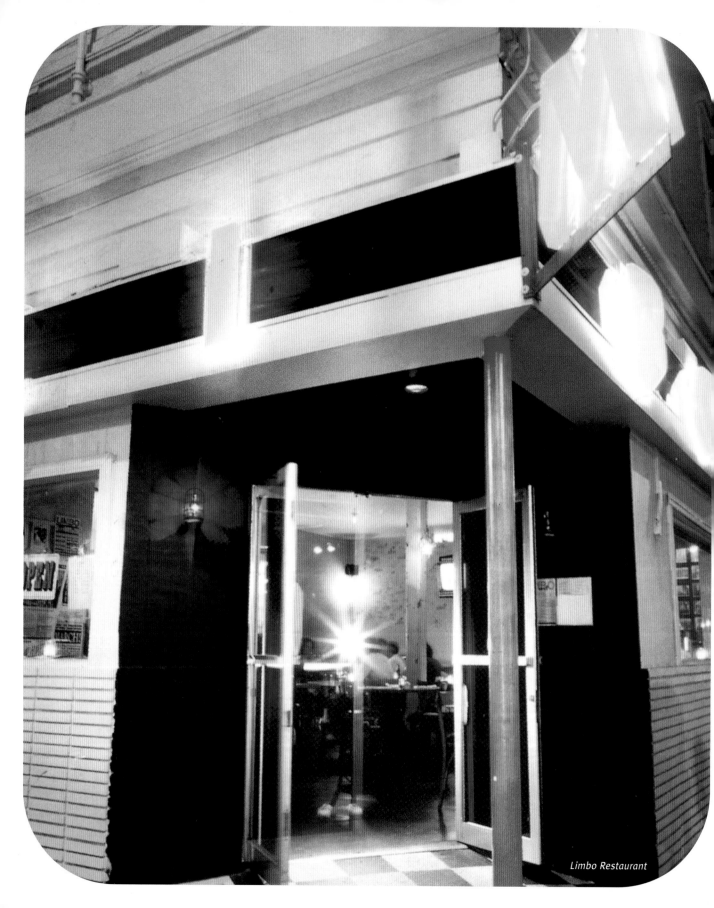

Limbo Restaurant

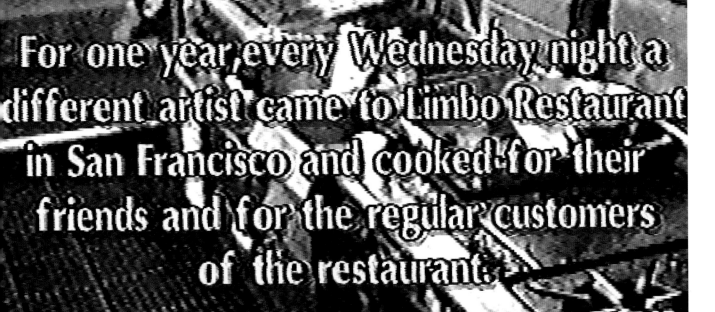

For one year, every Wednesday night, a different artist came to Limbo Restaurant in San Francisco and cooked for their friends and for the regular customers of the restaurant.

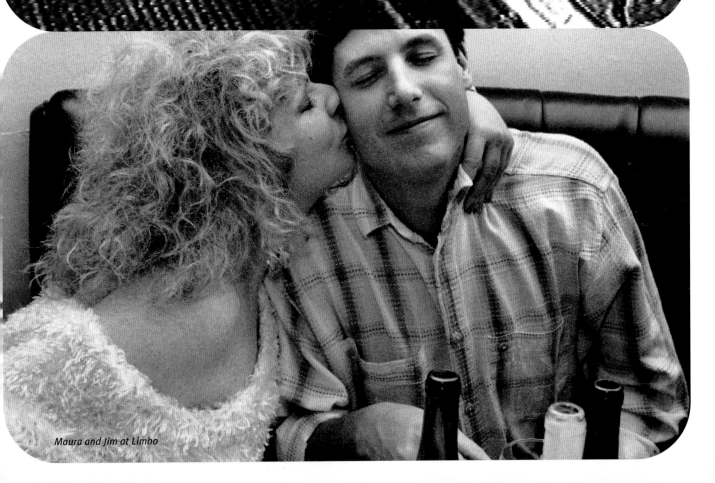

Maura and Jim at Limbo

Brian Routh

Kathy Brew's cooking assemblage

Maura Nolan, Rodney, and Tornedo

Matias Jaramillo

satisfied customer

Tony Labat

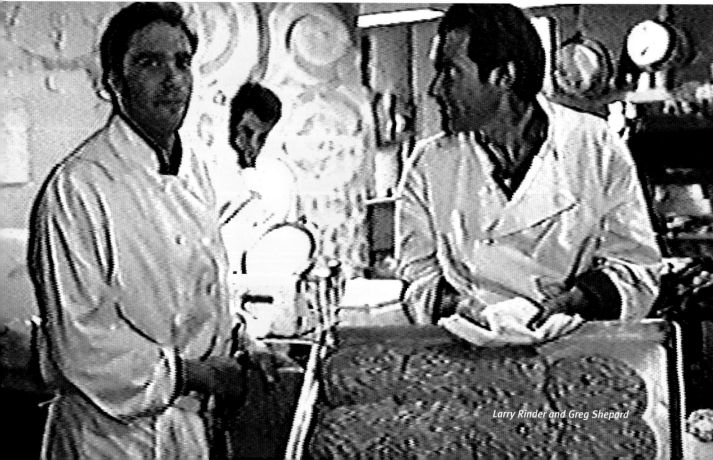

Larry Rinder and Greg Shepard

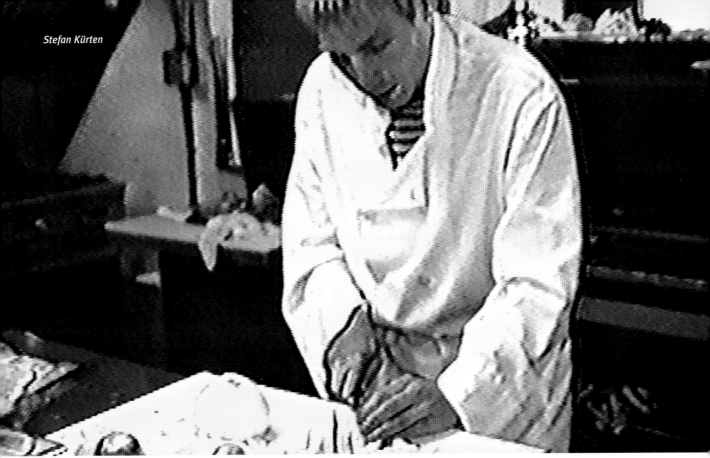
Stefan Kürten

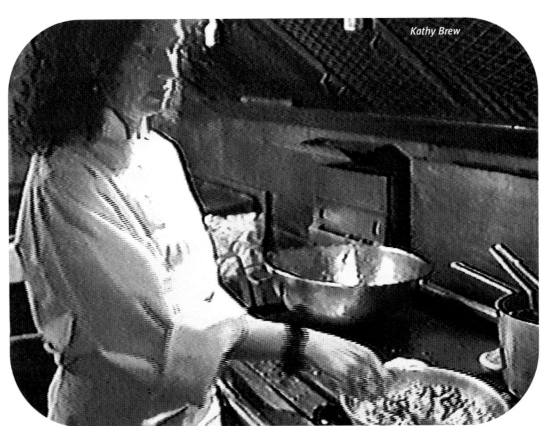
Kathy Brew

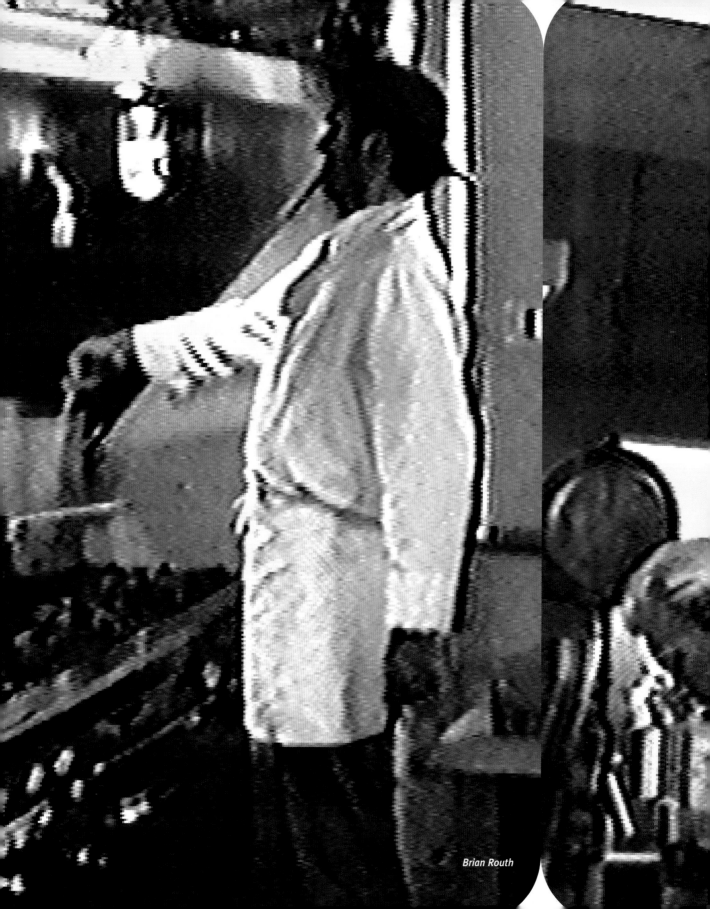

Brian Routh

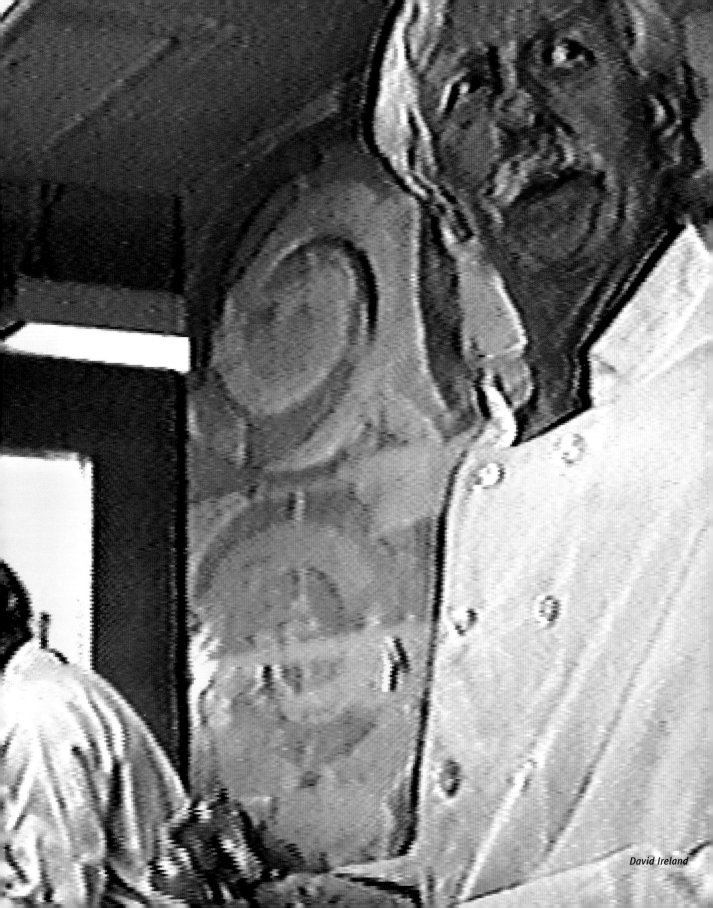

David Ireland

Kipper Kids

Stefan Kürten

Mark Paschall

nother satisfied customer

Irene Pijoan

ARTSPACE WAS ABOUT people

Stefan Kürten and Tony Labat, Making Shit, Summer Solstice

ARTSPACE WAS ABOUT shift

Shift

SHIFT

1
5

PART 1 | FEATURE 1

EXCERPT FROM *SHIFT 4*

The project for *SHIFT* coincided with a shift I had decided to make in my reading material for the summer. As of early June, I put myself on the art magazine wagon—there was to be no imbibing of specialized artwriting. It was my version of "gone fishing." I was looking for a non-aerobic sport and I had an angle. I wanted to see if anything had changed in the eighties about how the artist is portrayed within the context of the general culture. Therefore the lines I threw were into the mainstream. Older artists often say that today the decision to become an artist doesn't seem to entail the same risks, or sacrifices, as it did once for them. And there is plenty of evidence in the mass media that would suggest the archetypal image of the bohemian artist has been replaced by an iconization, exchanging the idea of artist as outsider for an insider who the media watches, it often seems, for

a different type of avant-garde information—about real estate, restaurants, and fashion, and getting there first. But whether or not a market goes over the top and over again, whether or not there are success stories that would suggest an immense value has been placed on contemporary art, there are still hundreds of thousands of artists with a different tale, and I was curious about the general drift about art, and themselves, which they may confront when they say " I am an artist." So I watched the news to see if there was any news on the image of art and the artist. There was the old news—the romance of the artist spurned, the Van Gogh/Gauguin model of failure to be appreciated in one's time, poverty, sickness, or having to leave "civilization" in order to find creative freedom. (In the end this type of biography still seems to have a greater box office appeal than the rare ego-strong, healthy as a bull, bull-market success story of a Picasso.) This summer the Gauguin show hit with perfect timing. In addi-

Shift to Shore

BY INGRID SISCHY

tion to the popular story there was the seasonal hook; the work seemed custom-made as every potential swimmer dreamed of oceans uncontaminated, and every potential lover of bodies virgin and therefore "safe."

Gauguin, however, is a giant fish as far as arts-and-leisure sections are concerned, and his is tackled with retroactive respect. The coverage on Gauguin is beach reading; you rarely finish it. It was my powder room literature which sparked an idea. If you want to inquire about the perspective of the nation as far as the arts there's a view that's on show in just about every issue of the *National Enquirer*. Here it's clear that contemporary art is still seen as a toon—a tune that strikes the same chords as that other popular hit, "the artist as madman." All decade we have spoken about art as a replacement for religion—the museum as church— we have watched movie after movie, turned page after page in the lifestyles stories, in which the presence of art is tantamount to an

emblem of eighties social "arrival." But go on a full tour, go to the magazine stands by the supermarket cash registers, and there you will find that art is still presented as a hoax. I don't want to single out the *National Enquirer,* my favorite source for Michael Jackson, or Brigitte Nielsen gossip, so I'd like to add that you could read a "highbrow" version of this approach almost everyday in *The New York Times* when Hilton Kramer was chief art critic—now you can find this mocking ambivalence in each issue of his *New Criteria.* A line I heard this summer relates. It is "I'm not bad, I'm just drawn that way" and the speaker is a Toon called Jessica in the movie, *Who Framed Roger Rabbit*. The picture is based on a book by Gray K. Wolf with a better title, *Who Censored Roger Rabbit?* And in the spirit of this question my contribution to *SHIFT* was originally called "Who Framed/Censored Art?" It was going to be about laughing at art, about wisecracks. Then the phone rang. *SHIFT*

"Samo© is dead" is what Jean-Michel Basquiat wrote over the cracks on a brick wall on a New York City building in 1979. This was not the death of another person which Basquiat was announcing. Jean-Michel Basquiat and Samo were one and the same person. From the writing of that obituary on, Basquiat's work started to carry his given name. "Jean-Michel Basquiat is dead" is what I heard when I picked up the phone in the middle of a sentence—in the middle of August—about cracks and art. The next day when I returned to the project, I filed my notes on the wisecracks. There are more important cracks to write about, less "fun" though. Like something feeling broken with the loss of Basquiat. There is also the issue of the crack as it pertains to the writing and the keeping of the record—history. Whether oral, whether tablets, or, say, a whole industry of schoolbooks, history-making in any of its forms is a product of selective memory, a sieve-like process in which almost all the content falls through the cracks. That which gets to remain is not only what is remembered of civilization, it is who we think we are, what we think we can or should do: it is consciousness and consciousness is what keeps humanity human. Without that, everything becomes "nasty, brutish, and short," in other words, life is over. Basquiat's place in all this is essential. First there is the crack he could have fallen through, remaining invisible, and we would be minus the record that he left, minus his contribution to our civilization which is a body of work that is critical—critical because it is about inventiveness, history, and making something meaningful out of what is found. Basquiat's use of the line as a critical instrument and as an expression of freedom, whether with words or with figures, is its own Declaration of Independence. The work is a contemporary model for creativity in contemporary conditions. And now that he is dead there is yet another potential crack that he will or won't fall through, depending on how the record of his life and his art is kept. Eventually they could just disappear. To lose either sight of the work or memory of the person is to be less

rich and more blind. To keep the cracks in mind that split his world and that were a formal element in his art—they were another way in which he used lines, not unlike Cy Twombly's invocation of marks as both ancient and modern, as both nature and culture—is to refuse to bury him. To refuse that, is to not forget either the man, his art, or the world in which it was produced—and on this more words are due.

Basquiat was a black man and as such his star status was an exception to the primarily all white "blue chip" artists who get to hit the Top Ten. The matter of color gave Basquiat's early success an even extra burden and he responded pointedly. I remember the ripples of shock he caused in a *New York Times Magazine* story that was basically about "hot artists" and high prices. Basquiat was on the cover in a fancy suit, but barefoot, and there was anecdotal information in the piece about his painting in clothes that had expensive labels. According to this article, he didn't bother to change and didn't mind spoiling the expensive outfits. These details elicited much "naughty boy" talk; people obviously prefer men in suits which don't tell the story of how they live; is that the province only for aprons and workclothes? Basquiat was against behaving as though he was "grateful"—he was right not to.

The pattern that Basquiat's reputation formed is not unusual within the fame machine. He went from being invisible, to become the talk of the town, and eventually to a place on the art world stage that was less brightly lit. His admirers continued, but for some he had used up what his friend Andy Warhol called your "15 minutes" and against that attitude, he, like many other artists, must have struggled. A quarter of an hour is a version of the "no longer interesting, no longer promising" tag and in the recent national as well as international shows you could see this view at work through Basquiat's absence. Yet Basquiat's inventiveness had not run dry. Now his death, apparently an accidental overdose which had him die in his sleep, has put an end to that promise. You

> Cracking and layering have been a ubiquitous style all through the decade as though these expressions were inevitable metaphors for a collective culture that feels unglued, unfixed, unsure about where we're heading.

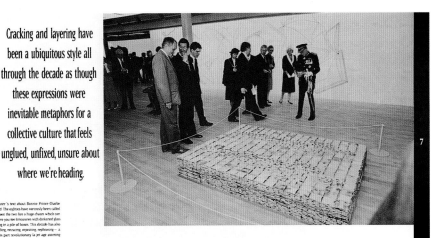

Charles Churchin at Gruenny Art in the National Enquirer 's text about Bonnie Prince Charlie chuckling at Antony Gormley's 'Bed' of bread. The eighties have variously been called the Age of Greed and the Age of Need. Between the two lies a huge chasm which can be witnessed here on any midtown block where you see limousines with darkened glass that cuts out the person only feet away living in a pile of boxes. This decade has also been an age of redoing other ages – of recycling, retracing, repeating, rephrasing – a neo-logical age of flotsam and jetsam that is part revolutionary la jet age zooming close in on the National Enquirer where they ran it in July 1988. The text that followed read: "This half baked art – a 60 foot square stack of stale bread – drew a chuckle from Prince Charles, who was attending the opening of a new art gallery at Liverpool, England. The wacky, offbeat sculpture depicts two figures lying down and is titled simply Bed. London artist Antony Gormley coated the stack of bread with wax to keep it from rotting away." Photo: Times Newspapers Ltd, London

could say "Why single out Basquiat, this kind of story happens to lots of people including those who no one ever notices?" Yes it does, and Basquiat's art, although utterly his, was also like a wall which anonymous others had marked up too. The paintings are the sharpest combination and the collective in one. *SHIFT*

May 1988, San Francisco.
Knock, Knock.
Who's there.
The artist David Ireland. He opened the door of his house. Anne MacDonald made the introductions. Into 500 Capp Street we went. This is a home where the cracks on the walls and ceilings have not been covered up. In fact they have been laboriously uncovered. Ireland has paid enormous attention to the articulations of cracks so that they become the veins and stars of his space, giving them a humanity you don't often see in restoration art and architecture.

Cracking and layering have been a ubiquitous style all through the decade as though these expressions were inevitable metaphors for a collective culture that feels unglued, unfixed, unsure about where we're heading. Ditto for an art community, in which it feels like there is a constant vacillation between excitement and disgust, between openness and retrenchment. This insecure shifting state is known by some as an era of posts and by others as a postponement of vision. But what you've got at Ireland's place is not post-modern pseudo-historicism. It's much less connived. It has a texture which is incredibly fragile, but it is also a model of conservation. To make art that can manifest such a sense of recognition is a double gift to the rest of us. It takes us home to our feelings about this moment and it shows time in a flow—looking at it we see the past (the history of the house), the present (the way the house seems to represent now), and the future (this doesn't seem like a house that's coming down). This work is decidedly non-apocalyptic. The crack environments Ireland has been working on predate, are very different than the crack houses we read about on the media beat but his works are also a perfect symbol for our time. They are similar to another image which has been showing up lately as part of the Zeitgeist— bridges, constructions which are about links, built for the very reason of crossing between places, and a starting point for moving away from the mood of dead end.

My parents used to take me to look at a bridge outside of Edinburgh called the Firth of Fourth Road Bridge. There were two stories about this bridge that the Scots always told. One is that no matter how hard the Germans tried to bomb it, the bridge was too strong. The other anecdote is about a man whose job was to paint the bridge, paying special attention to the cracks that would form because of the structure's tensions and also from weatherbeating. Every two years he would start at one end and work until he reached the other side, by which time he would have to begin again. One year he fell and drowned. It was impossible to look at the water even twenty years later and not think about him. After he died another painter got the job. I once met him at the refreshment stand on the side of the bridge closest to Edinburgh. I asked him if he ever got scared when he was working and if he thought about what happened to the other painter. He answered that in fact it was that other man who kept him up there because he felt as though they were doing the job together. And on those occasions when he got shaky and thought he could fall, the other man's voice would be right there with "Look across. Don't think about falling and if you do just say 'No, I won't'."

Every time I see or hear the current imperious slogan which uses those same three words, but with such a different tone, imparting its careless, fleshless edict in which "just say no" amounts to "drop dead," the thought of how each of these men kept each other alive through one man's memory and imagination is an antidote to the

round and round styles and history), and part archaic [this has influenced other terms we've heard used to define this time, such as Barbaric Age, Petrified Age, Frozen Age]. The crazy glue that holds all of it together can be tracked to our sense of being players in a curtain call — the end of the century. Doomsday sayers fear the show is finished, those with a more despotic role announce that the free-ride for the people without a part is over, and still others are waiting for the prologue to the next chronicle. Such a fin-de-siècle mood is always a time of Mannerisms, and ours has produced a huge canvas of fragment, visually, politically, and socially with all the Mannerist signs: unbalanced proportions, a mixed-up sense of scale, and a feeling of tunnel-like spaces that we can't see our way through.

The darkest of these worlds, where a current sense of no exit adds to the darkness, is officially in the province of science and medicine. Its effect is everywhere that sickness is endured, every place where loss and fear are felt. It was Jean-Michel Basquiat who wrote "disease culture" on a painting in 1982. No phrase could picture our challenge in a clearer way. Disease culture is what we're living with witnessing or living with AIDS, accompanied by the loss of so many individuals, amount-

ing to a situation in which much else seems very, very, small. Here is another subject where keeping people alive has to do with not accepting that people fall through the cracks, and with keeping their existence on record. One doesn't know what Basquiat was referring to when he wrote "disease culture", it is not clear whether he meant to describe conditions that are social, visual, political, or physical, or all of them and more. Anyway, as we have seen with this, as other diseases there is no neat boundary; social attitudes and politics define a disease as much as the scientists, affecting what it's like to live with a sickness. They can kill, too. They are also a sickness in need of a cure. That remedy won't come in the form of medicine but from the refusal to accept what is unacceptable. There are other critical lines going around, on buttons, on stickers, on banners, as chants, and they are activist responses to the dominant culture's response to this disease. Such as the group ACT UP's dissemination of the "Silence = Death" equation. Their use of this line is about criticism — about showing the cracks in justice — as a form of survival. It also suggests a bridge of sorts because its reach includes the idea of stopping death, of arriving on the other side of this abyss that we currently feel when we hear the word AIDS. No doubt the idea of a bridge can seem naive, like a rainbow painted in the middle of a horror story. But hope is not naive. It is far from useless. The opposite is true; hopelessness is an excuse for governments and scientists to stop trying, hopelessness is a crime against our right to expect a discovery that will bring about recovery. I mean to single out AIDS. And I mean to do so in the context of this section covering perspectives on and in the eighties. I don't want to keep it distant. It isn't. It has changed life, taken lives in every community, and each one lives with its pretense and with terrible absences, some more than others. Nor do I want to make it part of a list of tragedies. No tragedy should be reduced by such a perspective — it works to make tragedy acceptable. So I single it out in the same way it has singled out our time, giving our lives a fear of sex and a perspective on death that modern life never had. These feelings and this view are a vital part of the content that needs to be included in any discussion of the topic of contemporary perspective. Basquiat put the image of disease culture in the place where it belongs as a subject — the art context. Many of the most important artworks of this decade have done so too. And together they join a tradition which is about yet another crack and another bridge — the one where art crosses over into being a part of the world, and not apart from it. Shift.

Joseph Stella, *The Bridge*, 1922, oil and tempera on canvas, 88 1/2" x 54". Collection of the Newark Museum, New Jersey. Purchase 1937 Felix Fuld Bequest Fund. Panel 5 from *The Voice of the City of New York Interpreted* series, 1920-22.

Right: Michael O'Brien, *Silence = Death*, banner carried by ACT UP [AIDS Coalition To Unleash Power] in the Gay Pride March, New York City, 1988.

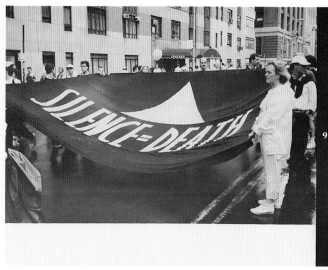

8

9

Marie Antoinette-ism of our present institutions.

Which brings us back to the *National Enquirer's* text about Bonnie Prince Charlie chuckling at Antony Gormley's "Bed" of bread. The eighties have variously been called the Age of Greed and the Age of Need. Between the two lies a huge chasm which can be witnessed here on any midtown block where you see limousines with darkened glass that cuts out the person only feet away living in a pile of boxes. This decade has also been an age of redoing other ages—of recycling, retracing, repeating, rephrasing—a neo-logical age of flotsam and jetsam that is part revolutionary (a jet age zooming round and round styles of history), and part archaic (this has influenced other terms we've heard used to define this time, such as Barbaric Age, Petrified Age, Frozen Age). The crazy glue that holds all of it together can be tracked to our sense of being players in a curtain call—the end of the century. Doomsday sayers fear the show is finished, those with a more despotic role announce that the free-ride for the people without a part is over, and still others are waiting for the prologue to the next chronicle. Such a fin-de-siècle mood is always a time of Mannerisms, and ours has produced a huge canvas of fragment, visually, politically, and socially with all the Mannerist signs: unbalanced proportions, a mixed-up sense of scale, and a feeling of tunnel-like spaces that we can't see our way through.

The darkest of these worlds, where a current sense of no exit adds to the darkness, is officially in the province of science and medicine. Its effect is everywhere that sickness is endured, every place where loss and fear are felt. It was Jean-Michel Basquiat who wrote "disease culture" on a painting in 1982. No phrase could picture our challenge in a clearer way. Disease culture is what we're living with witnessing or living with AIDS, accompanied by the loss of so many individuals, amounting to a situation in which much else seems very, very small. Here is another subject where keeping people alive has to do with not accepting that people fall through the cracks, and with keeping their existence on record. One doesn't

know what Basquiat was referring to when he wrote "disease culture"; it is not clear whether he meant to describe conditions that are social, visual, political, or physical, or all of them and more. Anyway, as we have seen with this, as well as other diseases there is no neat boundary; social attitudes and politics define a disease as much as the scientists, affecting what it's like to live with a sickness. They can kill, too. They are also a sickness in need of a cure. That remedy won't come in the form of medicine but from the refusal to accept what is unacceptable. There are other critical lines going around, on buttons, on stickers, on banners, as chants, and they are activists responses to the dominant culture's response to this disease. Such as the group Act Up's dissemination of the "Silence = Death" equation. Their use of this line is about criticism—about showing the cracks in justice —as a form of survival. It also suggests a bridge of sorts because its reach includes the idea of stopping death, of arriving on the other side of this abyss that we currently feel when we hear the word AIDS. No doubt the idea of a bridge can sound naive. It is far from useless. The opposite is true; hopelessness is an excuse for governments and scientists to stop trying, hopelessness is a crime against our right to expect a discovery that will bring about recovery. I mean to single out AIDS. And I mean to do so in the context of this section covering perspectives on and in the eighties. I don't want to keep it distant. It isn't. It has changed life, taken lives in every community, and each one lives with its pretense and with terrible absences, some more than others. Nor do I want to make it part of a list of tragedies. No tragedy should be reduced by such a perspective—it works to make tragedy acceptable. So I single it out in the same way it has singled out our time, giving our lives a fear of sex and perspective on death that modern life never had. These feelings and this view are a vital part of the content that needs to be included in any part of the discussion of the topic of contemporary perspective. Basquiat put the image of disease culture in the place where it belongs as a subject—the art context. Many of the

LONDON BRIDGE.
LONDON Bridge is broken down, my fair lady! / What did the robber do to you, my fair lady! / He broke my watch and stole my keys, my fair lady! / Then off to prison she must go, my fair lady!

Cracks and bridges as metaphors for this period, as symbols of vision, are of course almost contradictions. Technically a bridge is built over a crack, as it were, rendering the gap less of an influential force. But cracks are also the markers for places where bridges are needed, they are the starting point for new connections. There's a code of ethics in conservation that says when something is broken, say, a piece of fine art, it's important to show the cracks, to include where the damage has occurred as part of the act of repair. To cover it up would be shifty. The structure of a bridge is similar because you always see the chasm that motivated it.

Tunnels and tunnel vision are the inverse of bridges. There is no peripheral view. On tunnel vision I would like to quote a writer on manners whose subject is apt for our period of posts. Emily Post brings up another area where there are cracks that should be remembered and bridges that need to be built. What Emily Post wrote in her book Etiquette in 1922 was intended by her to be about New Yorkers, she said

New York's bad manners are often condemned and often very deservedly. Even though the cause is carelessness rather than intentional rudeness.

It is by no means unheard of that after sitting at table next to the guest of honor, a New Yorker will meet her the next day with utter unrecognition. Not because the New Yorker means to "cut" the stranger or feels the slightest unwillingness to continue the acquaintance, but because few New Yorkers possess enthusiasm enough to make an effort to remember all the new faces they come in contact with, but allow all those who are not especially "fixed" in their attention, to drift easily out of mind and recognition. It is mortifyingly true; no one is too ignorantly indifferent to everything outside his or her own personal concern as the socially fashionable New Yorker, unless it be a Londoner! The late Theodore Roosevelt was a brilliant shining exception. And, of course, and happily, there are other men and women like him in this. But there are also enough of the snail-in-shell variety to give color to the very just resentment that those from other and more gracious cities hold against New Yorkers.

In other communities, happily, the impulse of self-cultivation, if not the more generous ones of consideration and hospitality; induces people of good breeding to try and make the effort to find out what manner of mind, or experience, or talent, a stranger has; and to remember, at least out of courtesy, any one for whose benefit a friend of theirs gave a dinner or luncheon. To fashionable New York, however, lunch was at one-thirty; at three, other things are crowding at the moment—that is all.

I first read Post's description before I came to live in this city and it stays with me as an image of how solipsistic life here can be. I wish it were just New York, then we could declare it different. But tunnel visions and a schedule that has no memory, only an appetite for the next and the next, is a perspective one can find everyplace. SHIFT, this magazine, is especially important here; the word "shift" in fact is sometimes used when one's talking about a bid in a bridge game. And the next hand, just like the last hand, badly needs such a bid whether it's a call for a bridge between New York and San Francisco, between countries, or between each other—inch by inch, step by step. SHIFT

It has been said that the art of the eighties is without enduring value. I do not agree. Its chaos, and lack of definition, is meaningful because it is an art that reflects our fragmented sense of self and world. You could say that some of it is world-wise, the opposite of a Utopian vision. We can't afford another otherworldly vision which leaves us "ignorant where this River rises, whether in Asia, Africa, or in Utopia," as a line from a seventeenth century traveler goes. Asia and Africa are here; Utopia is nowhere existing and it is an idea for castle in the sky builders, not bridge builders

most important art works of this decade have done so too. And together they join a tradition which is about yet another crack and another bridge—the one where art crosses over into being a part of the world, and not apart from it. SHIFT

Cracks and bridges as metaphors for this period, as symbols of vision, are of course almost contradictions. Technically a bridge built over a crack, as it were, rendering the gap less of an influential force. But cracks are also the markers for places where bridges are needed, they are the starting points of new connections. There's a code of ethics in conversation that says when something is broken, say, a piece of fine art, it's important to show the cracks, to include where the damage has occurred as part of the act of repair. To cover it up would be shifty. The structure of the bridge is similar because you always see the chasm that motivated it.

Tunnels and tunnel vision are the inverse of bridges. There is no peripheral view. On tunnel vision I would like to quote a writer on manners whose subject is apt for our period of posts: Emily Post. This quote by Post brings up another area where there are cracks that should be remembered and bridges that need to be built. What Emily Post wrote in her book *Etiquette* in 1922 was intended by her to be about New Yorkers. She said: *New York's bad manners are often condemned and often very deservedly. Even though the cause is carelessness rather than intentional rudeness.*

It is by no means unheard of that after sitting at table next to the guest of honor, a New Yorker will meet her the next day with utter unrecognition. Not because the New Yorker means to "cut" the stranger or feels the slightest unwillingness to continue the acquaintance, but because few New Yorkers possess enthusiasm enough to make an effort to remember all the new faces they come in contact with, but allow all those who are not especially "fixed" in their attention, to drift easily out of mind and recognition. It is mortifyingly true; no one is too ignorantly indifferent to everything outside his or her own personal concern as the socially fashionable New Yorker, unless it be a Londoner! The late Theodore Roosevelt *was a brilliant shining exception. And, of course, and happily, there are other men and women like him in this. But there are also enough of the snail-in-shell variety to give color to the very just resentment that those from other and more generous cities hold against New Yorkers.*

In other communities, happily, the impulse of self-cultivation, if not the more generous ones of consideration and hospitality; induces people of good breeding to try and make the effort to find out what manner of mind, or experience, or talent, a stranger has; and to remember, at least out of courtesy, any one for whose benefit a friend of theirs gave a dinner or luncheon. To fashionable New York, however, lunch was at one-thirty; at three, other things are crowding at the moment—that is all.

I first read Post's description before I came to live in this city and it stays with me as an image of how solipsistic life here can be. I wish it were just New York, then we could declare it different. But tunnel visions and a schedule that has no memory, only an appetite for the next and the next and the next, is a perspective one can find every place. *SHIFT*, this magazine, is especially important here; the word "shift" in fact is sometimes used when one's talking about a bid in a bridge game. And the next hand, just like the last hand, badly needs such a bid whether it's a call for a bridge between New York and San Francisco, between countries, or between each other—inch by inch, step by step. SHIFT

It has been said that the art of the eighties is without enduring value. I do not agree. Its chaos, and lack of definition, is meaningful because it is an art that reflects our fragmented sense of self and world. You could say that some of it is world-wise, the opposite of a Utopian vision. We can't afford another otherworldly vision which leaves us "ignorant where this River rises, whether in Asia, Africa, or in Utopia," as a line from a seventeenth century traveler goes. Asia and Africa are here; Utopia is nowhere existing and it is an idea for castle in the sky builders, not bridge builders.

REASONS TO GET HAPPY BY KATHY ACKER

EXCERPT FROM *SHIFT 15*

ONE

I was born in New York City twice:

(1) As people are usually born. (to New Yorkers, 'New York' means 'Manhattan' and, actually, I was born in Brooklyn and, when a year old, moved my maternal grandmother and mother into the center of Manhattan.

Or so my mother told me. She wasn't fond of giving me information about myself or anything else; most of what she did tell me turned out to be fiction.)

(2) As an artist. My art medium is language. A prose writer, I was brought up by the New York art world. Title of my personal fifties'

pulp novel: Art-World Brat Goes Bad. In my whitebread world at age thirteen, I was so naive that I thought sex was something, an act?, which occurs when a male human and female human rub their naked asses against each other (I wasn't doing THAT!) and not knowing what 'virginity' was, I lost mine. At age fourteen, almost every other afternoon, I escaped from the private girls' school in which my parents had placed me and still in white middy blouse, blue wool jumper below knees, and white knee socks, traveled by subway, the entrance into all realms that were forbidden and dangerous, downtown. Into the world of art. There I met my current boyfriend, P. Adams Sitney, in his apartment building on 9th Street. Gregory Corso, who also lived there, would be shooting up in the hallway. Or else I joined P. Adams at the film Co-Op, then the center for underground filmmakers and related poets such as Robert Kelly and Jackson MacLow. Still in my uniform, I did not understand a word of what these grown-ups said to me or to each other. In those

ONE

I was born in New York City twice:

(1) As people are usually born. (to New Yorkers, 'New York' means 'Manhattan' and, actually, I was born in Brooklyn and, when a year old, moved by maternal grandmother and mother into the center of Manhattan.
Or so my mother told me. She wasn't fond of giving me information about myself or anything else; most of what she did tell me turned out to be fiction.)

(2) As an artist. My art medium is language. A prose writer, I was brought up by the New York art world. Title of my personal fifties' pulp novel: *Art-World Brat Goes Bad*. In my whitebread world at age thirteen, I was so naive that I thought sex was something, an act?, which occurs when a male human and female human rub their naked asses against each other (I wasn't doing THAT!) and not knowing what 'virginity' was, I lost mine. At age fourteen, almost every other afternoon, I escaped from the private girls' school in which my parents had placed me and still in white middy blouse, blue wool jumper below knees, and white knee socks, traveled by subway, the entrance into all realms that were forbidden and dangerous, downtown. Into the world of art. There, I met my current boyfriend, P. Adams Sitney, in his apartment building on 9th street. Gregory Corso, who also lived there, would be shooting up in the hallway. Or else I joined P. Adams at the film Co-Op, then the center for underground film makers and related poets such as Robert Kelly and Jackson MacLow. Still in my uniform, I did not understand a word of what these grown-ups said to me or to each other. In those days, I did understand that they, especially the eminent and huge critic, Parker Tyler, regarded me as their mascot, a miraculous simulation of the

Parisian whore who dresses up to be a school girl.
P. Adams made super-8 films of me taking off and then putting on my school uniform. Perhaps this was his version of porn. I loved porn. One day, he asked me to edit his magazine, *Film Culture*, while he was away in Europe. For the first time in this still new world, I was shocked, shocked because I knew full well that I was just a child and understood nothing: I did not understand how a grown-up man could think that I knew anything, much less enough to edit one of the finest contemporary film magazines.
Here was my entrance into the realm of art. Though I didn't understand what was being said to and around me, I did know that I wanted to live in P. Adams' world, rather than in the hypocritical society of my parents and their Wall Street friends. To me, art was not a business, not a vocation, belief, philosophy, even a practice: simply, art was a world in which one could live and, by living there, have the best of all possible lives. This was what I thought those Fluxus members, of whom Jackson MacLow was one, meant when they said, "Art is Life."
A certain incident clarified my discovery about what I wanted, this discovery of myself. One day, JFK died. I was now in the later years of high school and still running away from school, away to my other home in the East Village. When the announcement of the murder was made, everyone in school huddled around the T.V.. Teachers and students alike sobbed. I felt nothing. I was seeing pictures on a screen. Again, I escaped downtown. To the world which I still didn't comprehend, but desired in the way and with the same ferocity that much later in my life I would need in a lover.
In the Film Co-Op's largest room, the film makers there, I remember Adolfas Mekas and perhaps Gregory Markopoulos, grieved. Here, memory stops being accurate in regard to time. A day ago?, Edith Piaf had died. In response to her death, Jean Cocteau suicided. Cocteau had recently sent a drawing to the Film Co-Op, composed especially for those artists.
With the same intensity that I did not understand the mourning for the murder of JFK, I understood grieving the double deaths of Piaf and

SHIFTS

days, I did understand that they, especially the eminent and huge critic, Parker Tyler, regarded me as their mascot, a miraculous simulation of the Parisian whore who dresses up to be a school girl.

P. Adams made super-8 films of me taking off and then putting on my school uniform. Perhaps this was his version of porn. I loved porn. One day, he asked me to edit his magazine, *Film Culture*, while he was away in Europe.

For the first time in this still new world, I was shocked, shocked because I knew full well that I was just a child and understood nothing: I did not understand how a grown-up man could think that I knew anything, much less enough to edit one of the finest contemporary film magazines.

Here was my entrance into the realm of art. Though I didn't understand what was being said to and around me, I did know that I wanted to live in P. Adams' world, rather than in the hypocritical society of my parents and their Wall Street friends. To me, art was not abusivness, not a vocation, belief, philosophy, even a practice: simply, art was a world in which one could live and, by living there, have the best of all possible lives. This was what I thought those Fluxus members, of whom Jackson MacLow was one, meant when they said, "Art is Life."

A certain incident clarified my discovery about what I wanted, this discovery of myself. One day, JFK died. I was now in the later years of high school and still running away from school, away to my other home in the East Village. When the announcement of the murder was made, everyone in school huddled around the T.V.. Teachers and students alike sobbed. I felt nothing. I was seeing pictures on a screen. Again, I escaped downtown. To the world which I still didn't comprehend, but desired in the way and with the same ferocity that much later in my life I would need in a lover. In the Film Co-Op's largest room, the film makers there, I remember Adolfas Mekas and perhaps Gregory Markopoulos, grieved. Here, memory stops being

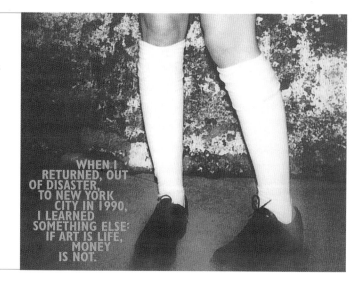

accurate in regard to time. A day ago?, Edith Piaf had died. In response to her death, Jean Cocteau suicided. Cocteau had recently sent a drawing to the Film Co-Op, composed especially for those artists. With the same intensity that I did not understand the mourning for the murder of JFK, I understood the grieving the double deaths of Piaf and Cocteau. I understood as one truly understands, through my flesh. And I vowed that I would work and one day I would be not just a pretty girl in a uniform, one day I would understand something and be a worker in a world of Piaf and Cocteau and in that way earn my right to exist in the art world which I desired. For art is life.

In those childhood New York City years and later, my time in New York City in my twenties, I learned something. I, like all New Yorkers, learned that New York City is the center of the world. In other words or worlds, outside of New York City the world does not and cannot exist.

Nevertheless my adult life was and still is that of wandering. First: moving back and forth, between New York City and California, every two years or so. Once that period was over, I began traveling to Europe until 1984, when I transferred to London permanently. Or so I thought at that time.

When I returned, out of disaster, to New York City in 1990, I learned something else: If art is life, money is not. Our society, our post-capitalist society is sick in so many ways. So many ways of announcing disaster. If faint memories and tracings still linger of times and cultures in which the leaders of a society (the politicians) and the actualizers of the imagination and of vision (the artists) worked hand-in-hand, nevertheless our overwhelming actuality is, as The Mekons say, "cruelty without beauty." Is isolation. Isolation of the artist; isolation of the dying; isolation of the living from their dead; isolation of emotion; isolation of desire; isolation of the human; isolation of the political; isolation of and by power; isolations within the self. Isolation or cutting off: our own lives are so cut off, cut up that we no longer remember vision, joy, or even human history. In this virtual reality, the

body and animal history have disintegrated. Under the sign of progress, we are destroying the bodies not only of others.

We can no longer know what art is.

It is impossible to live in a diseased society and not be diseased. Money, as symbol of that which devalues and separates, like all symbols, has become and becomes that which it symbolizes. The knife in the hole of our brains. As Cronenberg has shown repeatedly, our organs are now crawling away from our bodies, out of and back into horror. And I saw, in the days of my return to New York City, that money—to name the symbol—or the heyday of the Mary Boone Gallery-to name another symbol-had and was causing the equation "Art is Life" to mean "If living is horrible, art becomes an activity that in its isolation or marginalization, its necessary questioning of itself, contains and announces the distillation of horror."

I do not know if now is a time for healing. If our society has not reached its nadir, then there must be nadirs upon nadirs and enough is enough. I do know that now is the time that healing must begin. Therefore: now will be a time for healing. Simply, we have no more choice. it is time to begin vision, vision of all that has been, is and can be outside horror. Now it is time for artists.

This work cannot be done in a center, be that center New York City, the Pentagon, or the phallus, for any center symbolizes, this is, the centrality of power, some of whose other names are "separation" and "horror." I, for one, have seen enough horror; there is no reason to see anymore; and so I left New York City.

TWO

Most of the language we use is for the purpose of lies, for the purpose of manipulating other human beings. In order to fight isolation, I am looking for language that does not lie, the language of the body. And so I am searching for the body, the body which can never be isolated.

DAY ONE (This might not make any sense.)

The movement in my clit is like going, a
movement, in a wave my expectation this is still description

I haven't gone anywhere, to the realm, yet.

"strap" it begins

There is nothing: it is here that language enters:

1. To calm the irritation. Just calm the irritation. Where is the opening, the door that opens?

Irritation is happy to be touched, but if it turns too expectant or excited without relaxing, it will become rigid.

The arising is a single, growing cock;

2. lose myself (beginning to lose myself)

3. becoming music. The more I become it, the more I trust it, hold on, just hold on, follow, don't have to do anything else.

4. purely holding on. now, the more, the better. I'm there, I'm there, (have made the transfer to another person which is music) going over.

DAY TWO

It starts with bodily irritation, but then one has to forget the body, leave the body, leave the body until the body quivers uncontrollably.

messages will reach me from the lost sailor.

Entering the room. the dust.
Room after room like levels of the body. Here is no dialectic.
In this room, everything hands out: nipples scrape against air;
buttocks thrust out so that the asshole is open, and all that was
inside is now outside.

now it starts. it: actual touching. This is the beginning of feeling.

DAY THREE

It happened very fast and I couldn't stop it (in order) to write.
First, relaxing so that the ground, the body had become ground, was
able to feel sensation. To do nothing else. Then, my clit was alive.
 (Here's the problem with coming: One enters the territory whose threshold is coming and wants to stay there forever. While crossing the threshold, language is forbidden; having crossed, it's possible to have language.)
 As soon as my body relaxed into only being a receiver, I entered into music or began a journey that was rhythmic, wave-like, in time.
For wave in time = music. Each time a wave falls, I'm able to feel more sensation. Why? Something to do with breathing. When a wave falls, I exhale. Then, at the bottom of exhalation, the physical sensation has to be (already allowable allowed) strong enough and wanting or desiring enough for the whole to turn into physical sensation; at this point, still desiring where there's no body left to become desire, at this point failure, the whole turns over into something else.
 I have described the entrance into the other world where all is a kind of ease. This other world is also the world within dream.

Photo:
Kelly
Martin

Kathy Acker, copyright, 1992

15

I have a masturbation journal: as I masturbate, I try to hear language as it arises.

DAY ONE (This might not make any sense.)

The movement in my clit is like going, a
movement, in a wave my expectation this is still description

I haven't gone anywhere, to the realm, yet

"strap" it begins

There is nothing: it is here that language enters:

1. To calm the irritation. Just calm the irritation. Where is the opening, the door that opens?

Irritation is happy to be touched, but if it turns too expectant or excited without relaxing, it will become rigid.

The arising is a single, growing cock;

2. lose myself (beginning to lose myself)

3. becoming music. The more I become it, the more I trust it, hold on, just hold on, follow, don't have to do anything else.

4. purely holding on. now, the more, the better. I'm there, I'm there, (have made the transfer to another person which is music) going over.

DAY TWO

It starts with bodily irritation, but then one has to forget the body, leave the body, leave the body until the body quivers uncontrollably. messages will reach me from the lost sailor.

Entering the room. the dust.
Room after room like levels of our body. Here is no dialectic.
In this room, everything hands out: nipples scrape against air;
buttocks thrust out so that the asshole is open, and all that was
inside is now outside.

now it starts. it: actual touching. This is the beginning of feeling.

DAY THREE

It happened very fast and I couldn't stop it (in order) to write. First, relaxing so that the ground, the body had become ground, was able to feel sensation. To do nothing else. Then, my clit was alive.

(Here's the problem with coming: One enters the territory whose threshold is coming and wants to stay there forever. While crossing the threshold, language is forbidden; having crossed, it's possible to have language.)

As soon as my body relaxed into only being a receiver, I entered into music or began a journey that was rhythmic, wave-like, in time.

For waves in time = music. Each time a wave falls, I'm able to feel more sensation. Why? Something to do with breathing. When a wave falls, I exhale. Then, at the bottom of exhalation, the physical sensation has to be (already allowable allowed) strong enough and wanting or desiring enough for the whole to turn into physical sensation; at this point, still desiring where there's no body left to become desire, at this point failure, the whole turns over into something else.

I have described the entrance into the other world where all is a kind of ease. This other world is also the world within dream.

KAREN

George Kuchar

Bob Riley

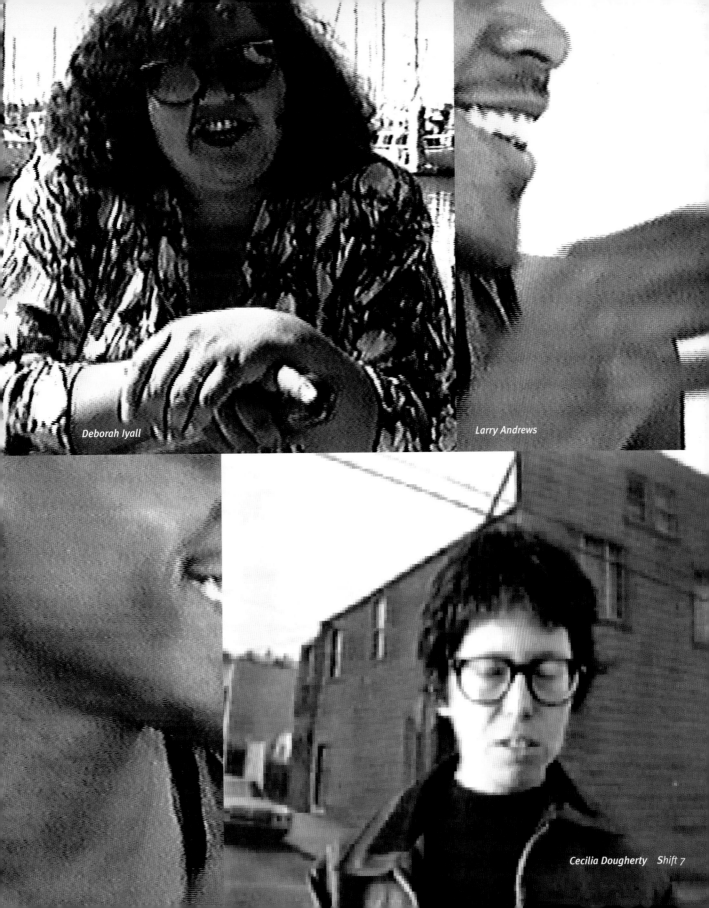

Deborah Iyall

Larry Andrews

Cecilia Dougherty Shift 7

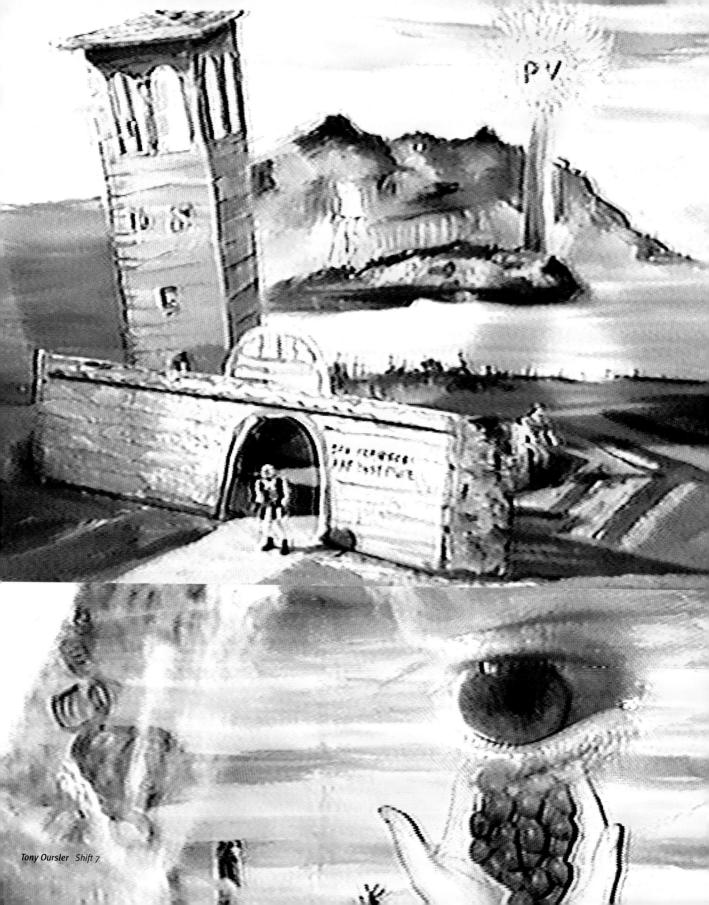

Tony Oursler *Shift 7*

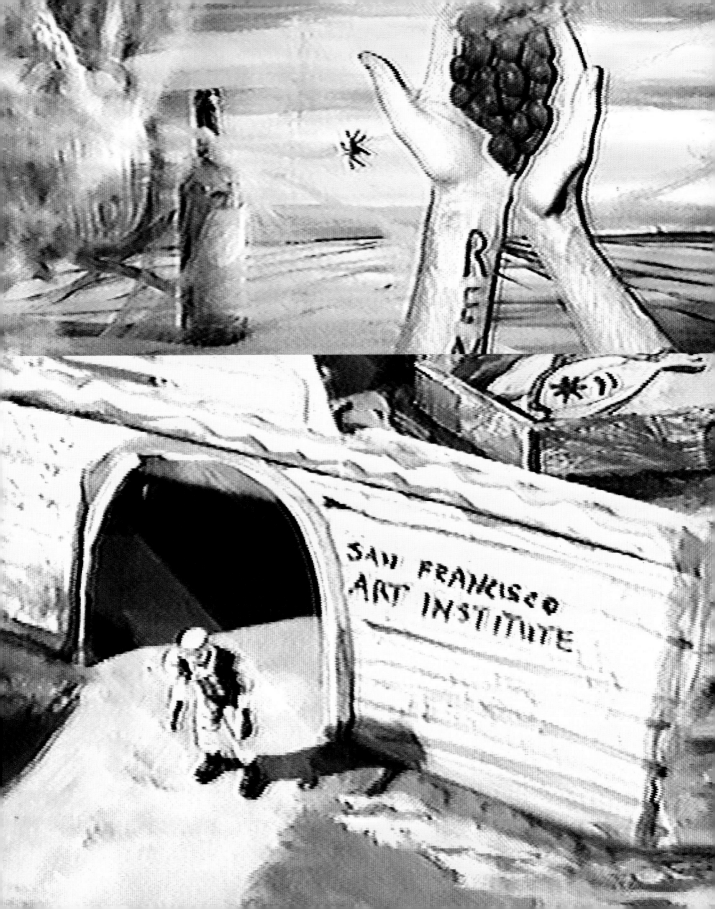

ARTSPACE IS ABOUT books

MEMORIES
THAT
SMELL
LIKE
GASOLINE

BY
DAVID
WOJNAROWICZ

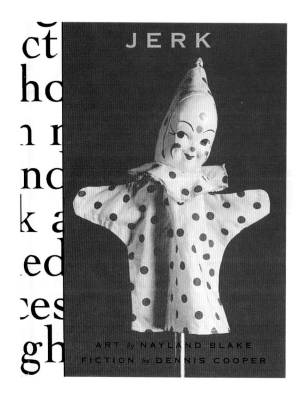

JERK

ART *by* NAYLAND BLAKE
FICTION *by* DENNIS COOPER

1

Back near the monitor the blazing light of the hand jerking the hardened dick is creating a blind spot to the right of it in the room and I can just about make out some silhouetted shape of a guy in shorts and shirt opened, knowing this because as he moves from dick to dick his shirt floats like a curtain billowing into light and disappearing again and he's got a baseball cap on. I'm moving into this blind spot to watch and he's on his knees sucking some kid's prick. There's an old man in the darkest shadows his flesh is a bland color just a dead white, emptied of blood and he seems afraid of the light keeps shifting weight from one foot to the other in a squatting position at some point the sucking guy has his back to the old man and he's leaning over the ledge to get another guy's prick in his mouth and the old man takes a large hand and peels the guy's shorts down in a slow motion insistence and soon has his tongue planted firmly between the guy's cheeks. The guy starts rolling his ass in the air in circular motions and continues sucking the prick of the stranger before him. The old guy is lapping away like a puppy with a bowl of milk and I'm standing there in the darkness and there's a stream of water or something snaking across the floor and the pale glow of faces staring towards us at the monitor that I can only see sideways and on the angled screen

when I was 9 or 10 some guy picked me up in central park + took me home. He made a polaroid of me sitting in a chair. It didn't show my face so I let him keep it.

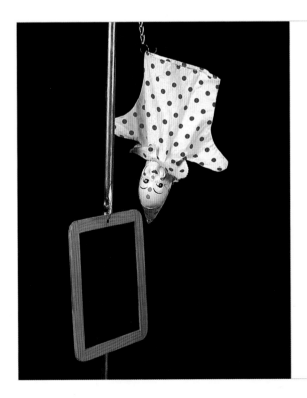

"Man," Brad whispers, obviously meaning yes plus an exclamation point or two.

"Cause it turns me on royally," Wayne scans the labels. "How about Wesley? I'm particularly proud of how I acted with him."

"God, I don't know about this Wayne,"

mumbles David. He's still over on the couch, hugging himself really tightly.

"Relax." Wayne starts threading film through the projector. Brad sits crosslegged in the middle of the room. He straightens out his posture, hands on knees, staring straight ahead at the empty screen like it's the Maharishi or something. Wayne

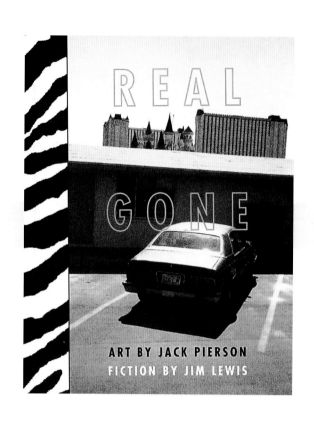

REAL

GONE

ART BY JACK PIERSON

FICTION BY JIM LEWIS

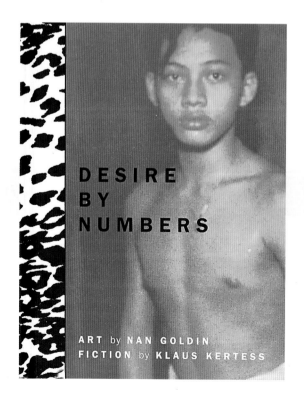

DESIRE
BY
NUMBERS

ART by NAN GOLDIN
FICTION by KLAUS KERTESS

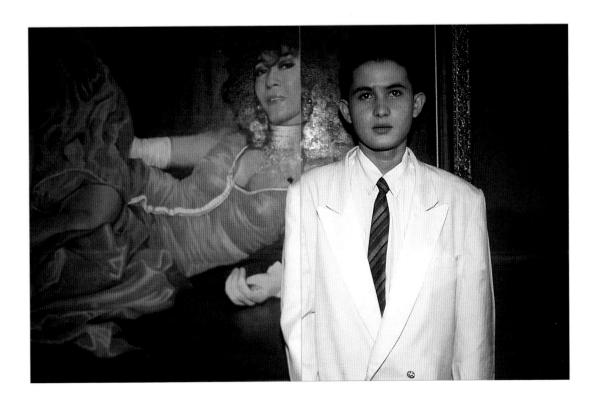

DAVE HICKEY

GEMINI

The sky was turning murky blue-beige when they came out of the after-hours place in Chinatown. Steve, the limo driver, was taking a nap behind the wheel of his Lincoln. She knocked on the window. He ran the window down, and she shared a little bump with him, reaching through the window to hold the spoon under his nose. Then they headed uptown. After they dropped the artist off in Tribeca, she settled back into the soft leather seat and smiled one of her famous, triumphant, fashion-magazine smiles, enjoying the deserted streets and thinking to herself that she was, in fact, one hell of an art dealer. Not a *great* art dealer, perhaps, since she had more of an ear than an eye, and not a *classic* art dealer, either, since she preferred selling to counting (That was her motto, "Sell don't count!"), but when the conditions were right, as they had been yesterday, when she could set the poetry of commerce in motion, as she had done, she could fucking sell some art.

It had been a beautiful autumn afternoon, perfect for an opening. The gallery had looked great. The art on the wall was a cut or two above average, and the artist had the sense to dress down. He arrived on foot looking like a Gen-X street person, which, naturally, made *her* look more powerful, which was good, since she had to sell the shit — and since she liked the way things looked, and the way *she* looked, and the way she felt, she sold a lot of it. People *always* wanted to buy. She knew this, so she would put on her serious smile, look into their eyes and mirror their desires, investing those desires with her own confidence and energy. Soon the sparks would fly. Then they would buy anything. Anyone would. She could sell anything to *anyone* — except to actors, who had always been a problem. Actors would put on their serious smiles, look into her eyes and mirror her desires, investing her desires with their own confidence and energy — and she would fall in love with them. Fortunately, New York was not Los Angeles, and there were not many actors to distract her from business, so a garden of red dots bloomed on the price list as the opening progressed.

Afterwards, at the dinner, the artist had been as giddy as a school girl. Sitting there like Louis Fourteen in a Corbu chair, in his faded *Joy Division* T-shirt, in his torn jeans and work boots, he happily drove the sommelier crazy about the wine, revealing himself to be just who he was (a labor lawyer's son from Grosse Pointe) but the Frenchman didn't mind a bit, because high spirits are infectious. *Winning* is

infectious, she knew, and most of all *money* is infectious, so they arrived at Larry and Jeff's giggling. They giggled all the way up the elevator, like bubbles rising in a glass of champagne, and stepped out into the living room feeling entitled to *everything,* entitled to the dazzling view that lay before them, to the perfect snacks, entitled, even, to the silver bowl of cocaine that Larry and Jeff kept on the Italian marble coffee table as a nostalgic offering to the lost spirit of the eighties.

Everybody hated the eighties now, because so many people had died, but *nobody* hates a silver bowl full of Peruvian cocaine. So they all did lines, just like old times, and got powder on their noses. They gobbled shrimp and other goodies seasoned with condiments and spices that Larry and Jeff had to explain in some detail. After an hour or so of coke, snacks and the view, they all set off for Chinatown. Before they left, however, she folded a hundred dollar bill and shoveled some toot into it — a small care package for Steve who was waiting downstairs with the car. She was good about details like this. People commented on it. They said it made up for her temper, and she hoped it did. Later, at the club, she introduced the artist to some actors whom she *knew* to be gay, although she nearly fell in love with them anyway as they all danced and shouted and dripped with sweat in the dazzled darkness.

Heading uptown through the gray morning in the back seat of the limo, she reviewed these events carefully and fumbled around in her purse, managing to locate her gallery keys but not her home keys, which she invariably mislaid. "Forgot my keys again, Steve," she said. "We need to drop by the gallery." "Yo," Steve said and hung a left, heading for Chelsea. A few minutes later, while Steve waited out in the car out in the brightening street, she took a seat behind her cluttered desk and surveyed the wreckage. She shuffled around for a moment, feeling for her keys and, not finding them, began stacking things. Invoices here. Messages there. Checks over there. The pile had been accumulating for a week so there were a lot of checks, and even though she did not like to count, she ran the numbers in her head. Just to see. A hundred and seventy-two thousand dollars worth of checks. Loose on her desk.

She fucking *loved* it! And she loved just sitting there at six in the morning behind her desk. So she sat there for a few moments luxuriating in the brightness and whiteness of everything. Then, on top of the message pile, she noticed a call from Houseman in London, and London was what? Plus five. Hell, she could call now, and then call the people in Zurich, get that out of the way, and do some desk work before the staff came in. Why not? She could change here and maybe take a nap after lunch. She nodded firmly, pushed herself up and, with a quick step walked back through the gallery and out onto the street. She knocked on the driver's window of the Lincoln.

"Hey, Steve!" she said, "You go on. I'm going to stay here."

Steve ran the window down.

"Got daytime shoes?" he asked.

"Flats and heels," she said, "You get some sleep."

"Be dreaming of you, babe," Steve said and, touching his cap, drove away down the empty street.

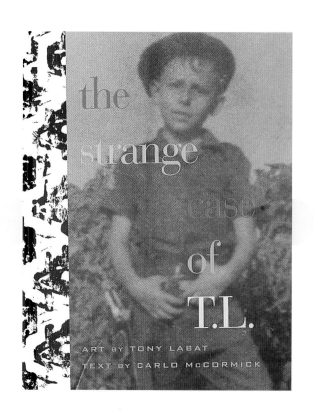

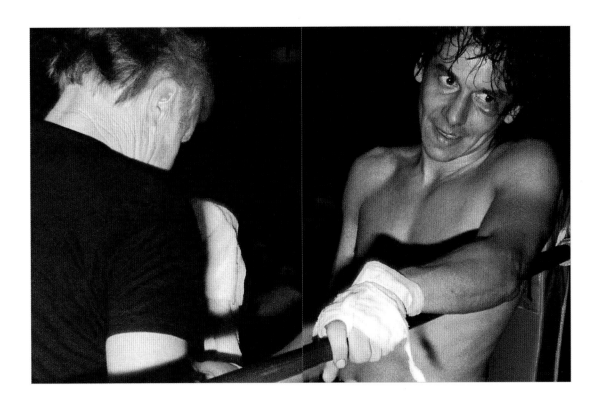

FD-263

FEDERAL BUREAU OF INVESTIGATION

REPORTING OFFICE	OFFICE OF ORIGIN	DATE	INVESTIGATIVE PERIOD
Albany, NY	Albany, NV	8-28-71	

REPORT MADE BY: Special Agent K. Willers TYPED BY: A.M.H.

TITLE OF CASE
Appendix A

CHARACTER OF CASE An elaboration on the novel The End Of Alice, exploring ███ the process of creating a character and the building of a fiction.

Appendix A contains the clues which permitted the author into the narrator's mind—becoming archetypical icons for the narrator's imagination. A book of physical evidence, the appendix documents the items one imagines the narrator hid during his twenty-three years of incarceration, remnants of his relationship with a little girl called Alice; teeth, ███████████, watch, ███████, ███████, letters from his correspondents, various forms and his photo album. This scrapbook, collected by the author during the five years it took to write The End Of Alice, is illustrative of not only key events in the narrator's life, but of the fluidity and fragmentation of identity and functions much like a photo insert in a true crime paperback—a kind of liquid proof. And finally there are the paintings, incorporating elements of collage; the photographs, the physical evidence, the text. Translating voice into gesture, the paintings are a further articulation of the life of a character, an investigation of the act of writing a novel such as ███████████, and ultimately an amalgam of both the character's impulses and the author's experience of the novel.

APPROVED _____ SPECIAL AGENT IN CHARGE DO NOT WRITE IN SPACES BELOW
COPIES MADE:

4500 published by San Francisco Art Space; distributed by DAP

FBI CASE REPORT

Dissemination Record of Attached Report			Notations copies to:
Agency		X	Anne MacDonald
Request Rec'd		bc	Maureen Keefe
Date Fwd		8-30-71	Kristin Johnson
How Fwd		cert	Sarah Chalfant
By	KW		Jamie Wolf

COVER PAGE

FBI/DOJ

I'll say this for Chubby Bascomb, he isn't cheap. I had been working for him for maybe three weeks when he sent me to courier the Mayan cylinder, but that didn't matter to Chubby. I worked for Bascomb Fine Arts, a class operation, so a limousine showed up at the gallery to take me to La Guardia. A first-class ticket flew me to Dallas, and another limo was waiting to drive me over to Art Crating and Shipping, which is located in an anonymous building in a landscaped industrial park not far from the airport. As a consequence of all this pampering, I was feeling pretty fat and happy as I walked up the sidewalk. This was just as well. When I opened the door, a big guy in khakis and a blue short-sleeved shirt was standing beside the desk screaming at somebody on the telephone. He had a helmet of kinky black hair, thick black eyebrows and very little brow between them. He looked like a goombah from upstate, which, as it turned out, he was.

He slammed the phone down and acknowledged me.

"Hey, kid," he said, "You from Chubby?"

I nodded and handed him my card.

"'Derek,'" he said, reading the card, "'Derek Chambers,' Jeez." He looked up at me and stuck out his hand. "Ernie Restante" he said, "and, Derek, you got a choice. You can sit on your butt for a couple of days over at the Mansion over on Turtle Creek, or you can come take a ride with me. Get the cylinder."

"I'll take the ride," I said, because Chubby had instructed me to go with Ernie wherever he went. Chubby had the cylinder sold, and he didn't want anything happening to it.

"Got luggage?" Ernie said.

"Just this."

"Well, grab it and let's roll."

Twenty minutes later, we were rolling southwest out of Fort Worth on Texas 377 in the luxurious cab of Ernie Restante's eighteen-wheeler. It was like sitting in the third balcony of a Broadway movie house. Perched vertiginously aloft, I stared almost directly down at the pavement that was swooshing under the truck. When we got into a cruising gear, Ernie slammed in a Replacements tape and cranked it up to stun.

"Old times," he shouted over the tape. "Except for gigs like this, I don't drive much anymore. Here, take one of these!"

He held out an enormous paw. There were five or six green spansules in it. Judging from his tone, I didn't seem to have a choice, so I took one. It was the first speed I'd taken since my Northern Baroque exam at Providence, but why not? I felt like a complete dork in my tassel loafers and gray slacks, in my Brooks blazer and nice white shirt and Italian tie. The Replacements were battering my ear drums. West Texas was rolling under my feet. There were cows in the fields through which we fled. After a while, I took off the tie and put it in my pocket.

We were an hour or so down the highway and listening to The Dead Boys when Ernie turned down the volume and said:

"So you're an art guy, huh, Derek?"

"Yeah, I'm an art guy," I said.

"Me too," Ernie said, "Art and books, those are my things, which is why I started Art Crating and Shipping. It's kind of a sideline and kind of a front, too, but it's not completely bogus, because I dig art, read everything I can about it." He reached behind the seat and pulled out a battered copy of *Manet's Modernism* by Michael Fried. "You read that?" he asked.

"Yeah," I said.

"It's mostly bullshit, but some okay," Ernie said. "And, my friends, Jesus, what fucking animals. They're into *en-ta-tayn-nahz!* They go to Vegas to see Buddy-fucking-Hackett, and what's *that* about? I can't believe it. Me? I say, fuck Vegas. I'm Italian. I take the wife, we go to Italy. To Venice. I got a friend there lets me stay in his palazzo, and even my friend says 'Ernie, you're welcome here, but you got family in Palermo. Why aren't you in Palermo seeing your great aunts?' I say, 'Fuck Palermo, and fuck my great aunts,' because, trust me, Derek, Sicily has got shit for paintings. But *Venezia*, she got some paintings! But this old gonif just looks at me. He's got a fucking *palazzo*, you know, and a dock on the Grand Canal with a power boat tied up to it, and he's never even seen the Tintorettos, never seen the fucking Tiepolos. He don't even go to *church*, this guy. He goes to *Vegas*. . . to see Buddy Hackett. Jeez."

"I got friends like that," I said, trying to think of one.

"So you know, then?" Ernie said, "You're an art guy like me. So you understand. You know why I like shipping this shit around, crating it up and delivering it. Doesn't matter what: old, new, Surrealist, Impressionist, Fauve, whatever, just so it's the quality shit. You got to be compartmentalized to do it, though. You treat it as a goof or you go postal. Because, trust me kid, the art world is all crooks. Chubby-fucking-Bascomb, your boss and my old pal, is a fucking *crook!* Ernie Restante, he's a *criminal*, and there's a big fucking difference I can tell you. Crooks think they can get away with all this little-bitty shit, so if I take this business seriously, I break Chubby's legs a time or two, all the sneaky shit he pulls. But, hey, he lets me haul the quality stuff. Just last week I'm riding along with four Joe Goode milk bottles right where you're sitting, so what the hell? And I'll earn some dough tonight, too, but not from the cylinder. The cylinder is a push. I just want to see it."

Ernie fell silent at this point, and I sat there thinking about Ernie breaking Chubby's legs. How would he do it? With an aluminum baseball bat, I decided. This made me extremely aware of my own legs which, for the moment at least, were blissfully and completely intact.

At sunset, we rolled into San Angelo on Texas 67. The sky was a lipstick-red dome. Beneath its immensity, the town looked small and blanched as it slipped past our windows. About twenty-five miles further west, out on the bald prairie in the absolute middle of dusty fucking nowhere, we turned south on Farm-to-Market 915.

"You're looking for a little sign that says Red Roof Ranch," Ernie said, "Should be somewhere in the next ten miles. On your side. There'll be a cattle guard."

It was nearly ten miles, but we found the sign and Ernie steered the big truck over the cattle guard onto

a dirt road. Soon we were heading west in full darkness under a billion stars. Ernie didn't say anything. He just drove. Once, he gave a little, one-finger wave and I glimpsed a Mexican in a straw hat standing off in the mesquite with a rifle under his arm. After about an hour, the dirt road curled up over a ridge, and, reaching the top, we suddenly found ourselves looking down into a small valley where about fifteen trucks were parked with their lights on. A few of them were vans, but mostly it was big rigs like ours, parked in two rows facing one another. Between them, a strip of graded road ran for about half a mile along the swale of the valley, its surface illuminated by the headlights. At its south end, the grading ran for about a hundred feet into a small hill that had been cut out to accommodate the road, making a little cul-de-sac canyon. Two yellow bulldozers crouched atop the hill on either side of the cut.

"What the hell is this?" I said.

"Capitalism in action," Ernie said. He guided his rig down into the valley and pulled into a slot in the east row of vehicles. Leaving the lights on and the diesel rumbling, he opened the door and climbed down.

"Meet me at the back," Ernie shouted, and by the time I got there, Ernie was deep in the empty trailer, working on the cab-side wall with a power screwdriver. I climbed into the trailer and he handed me a tall panel. "Lean this outside," he said. He was removing a false wall. Behind it, there was a hidden compartment about five feet deep. When we had the panels out, Ernie climbed down and walked back to the front of the truck. He lit a cigarette and looked at his watch.

"Twenty minutes," he said, so we stood there. A couple of guys came over from the other trucks to say hi to Ernie, but Ernie himself stayed put. Between visits, he explained that, because he was a "made" guy, he didn't have to walk around making nice. Twenty minutes later, we heard the roar of the plane, then, suddenly, it was right there in front of us, big and surprising, an old DC-9 painted olive drab, coming in low and fast, rushing past us in the headlights, wobbling. It hit the ground hard with a screeching crunch, bumped half-skewed about three quarters of the way down the grading and stopped. Two guys driving forklifts headed out to greet the plane. The truckers started turning off their headlights, except for the ones on the plane's door which opened immediately. Three Mexicans dropped a ramp from inside and came strolling warily down it. One of them carried a clipboard. The other two were carrying automatic pistols with long, curved, military clips.

"Stay here," Ernie said and strolled casually out toward the DC-9 where they were already off-loading bales of weed in a very efficient manner. Even so, it took the rest of the night to empty the cargo bay of the plane. Somebody would talk to the guy with the clipboard and hand him a brown, legal-sized envelope. Clipboard would check his list, check the envelope and call the guys with the forklifts. They would off-load the bales and drive them over to one truck after another. The trucks would leave as soon as they were loaded, pulling up over the rise and disappearing. We were last in line, so we had a long wait. I found myself wishing I had another green pill. When Ernie finally came back, hanging off the side of the lead forklift, the sky was purple. The Mexican guys helped fit the bales into the hidden compartment. Ernie and I reinstalled the false wall, and Ernie closed the trailer, locking it with a combination. Then, he turned to me.

"Come on," he said, "It's art time." This time, we walked out to the plane together. I stood there while

Ernie jabbered in Spanish with Clipboard. Clipboard yelled something into the plane. A litle guy wearing white peasant pants came scurrying down the ramp carrying a small aluminum crate. Ernie handed Clipboard another envelope. He checked it and nodded to the guy in the white pants, who handed the crate to Ernie. Ernie set the crate on the gravel and pulled the power screwdriver off his belt. While he was unscrewing the box, the Mexicans started pushing the DC-9 into the cul-de-sac at the end of the runway. When the DC-9 was totally enclosed by the sides of the artificial canyon, the bulldozers cranked up and started pushing dirt down over the old plane, burying it, like a dead brown bird. While this was going on, the sun broke over the ridge behind us and lit the 'dozers up bright yellow. They looked like giant locusts in their gauzy, flame-shaped plumes of dust, and since it was the scariest, weirdest thing I'd ever seen in my life, I turned to say something to Ernie, but he was oblivious. He was holding the Mayan cylinder in his hands, gazing down at it in wonder.

"Would you fucking *look* at this," he said, turning the cylinder in his hands. "Come on, Derek, *look at this!*" he said, so I stepped over and looked. "You see right there, Derek? That's the Jaguar King. He's the head dude, so he's got to do this blood sacrifice for his kingdom. And right there, coming out of his jaguar cloak? That's his pecker . . . his shlong. He's had to pierce it with a knife and run this purified strip of cloth through it. That's the ritual, so his blood will flow into this bowl and save the Mayans' civilization. See? There's the blood coming down, and there's the bowl."

"Yuk," I said.

"Yeah," Ernie said, "but it's not so weird, really. You been to Sicily, kid, it ain't weird at all." Grasping the cylinder in both hands, Ernie Restante suddenly lifted the ancient vessel above his head to catch the morning sunlight.

"Beautiful," he murmured, gazing up at it. "The damn thing is fucking *beautiful*," he said again, "and older than a bastard."

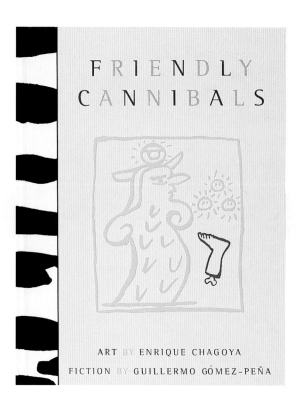

FRIENDLY
CANNIBALS

ART BY ENRIQUE CHAGOYA
FICTION BY GUILLERMO GÓMEZ-PEÑA

The Fae Richards
Photo Archive
~

Zoe Leonard, photographer
Cheryl Dunye, filmmaker

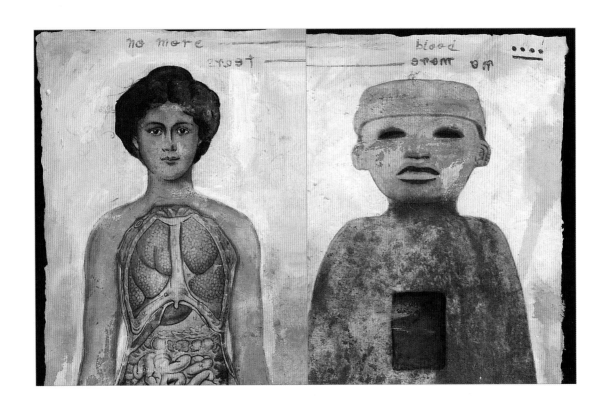

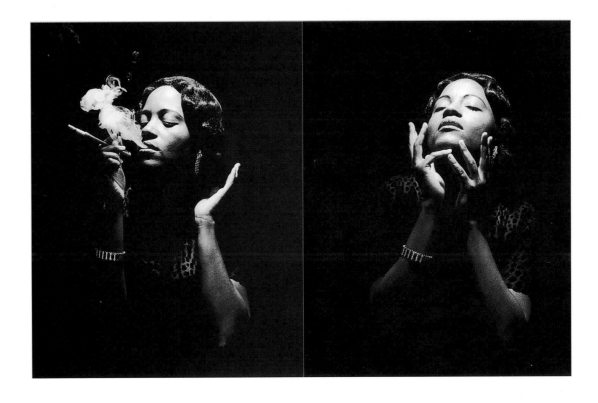

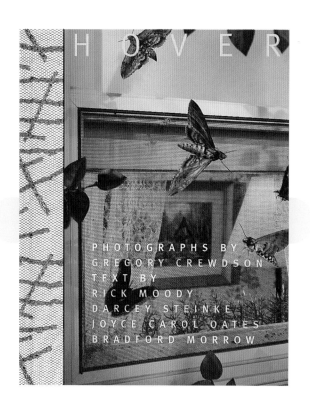

HOVER

PHOTOGRAPHS BY
GREGORY CREWDSON
TEXT BY
RICK MOODY
DARCEY STEINKE
JOYCE CAROL OATES
BRADFORD MORROW

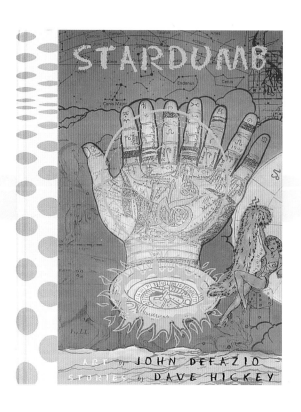

STARDUMB

ART by JOHN DEFAZIO
STORIES by DAVE HICKEY

Ten-year-old Janet encouraged tadpoles to release their tails and advised the squirrels on tea party etiquette and what sort of presents little girls liked at Christmas. Not that she had—as her mother sometimes accused—delusions of grandeur; this certainly wasn't an enchanted wood. Five acres at best, boxed in by strips of subdivision ranch houses, the asphalt parking lot behind her father's church, and at the far end an abandon chicken coop, which on downwind days could still drive a scent so evil through the trees that the children were forced to play indoors. It was not lush enough for Eden; no giant flowers or snakes rose up to speak with you. No matter how hard she pretended, these woods were still filled with plastic garbage bags and disintegrating diapers. An eviscerated automobile lay sprawled out in the stream bed and there was lots of broken down baby stuff; busted playpens, mud-caked car seats.

25

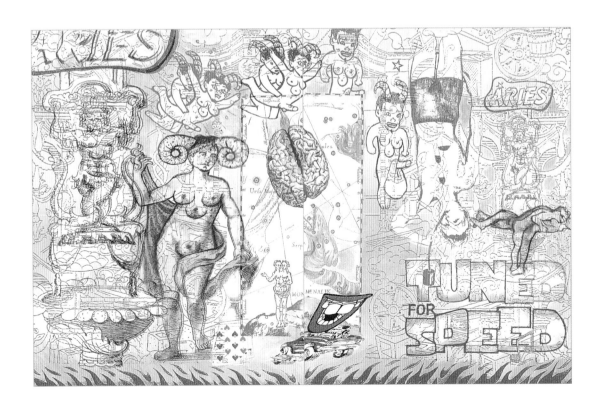

AND moving pictures

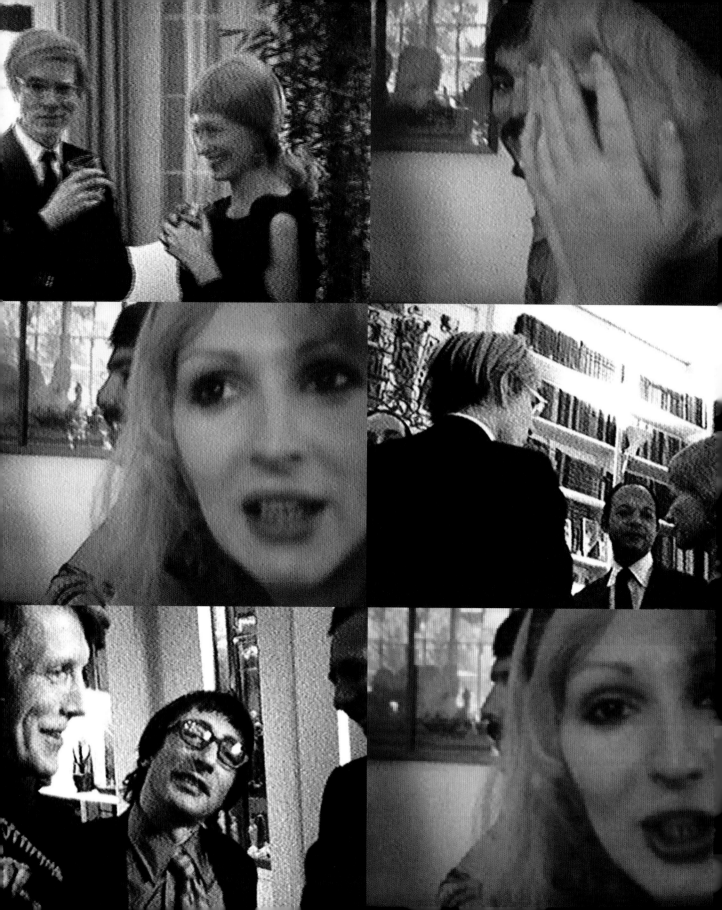

Lunch Movies

Lunch Movies

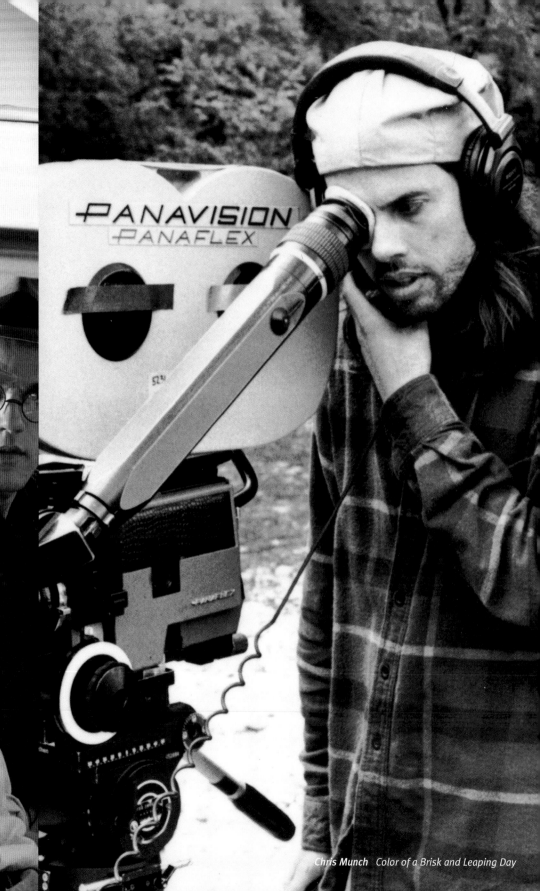

Chris Munch *Color of a Brisk and Leaping Day*

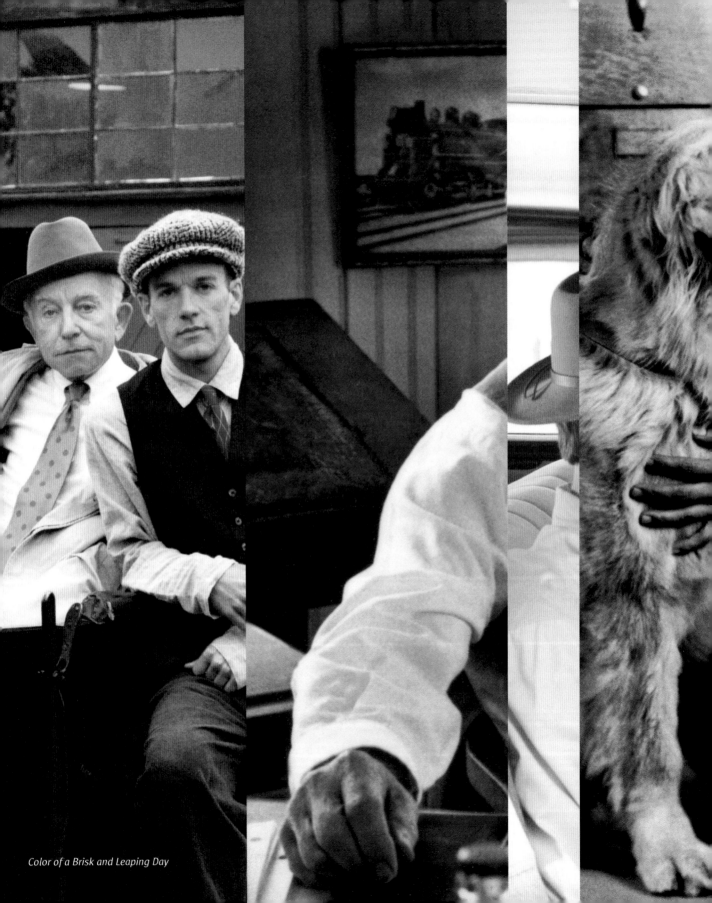

Color of a Brisk and Leaping Day

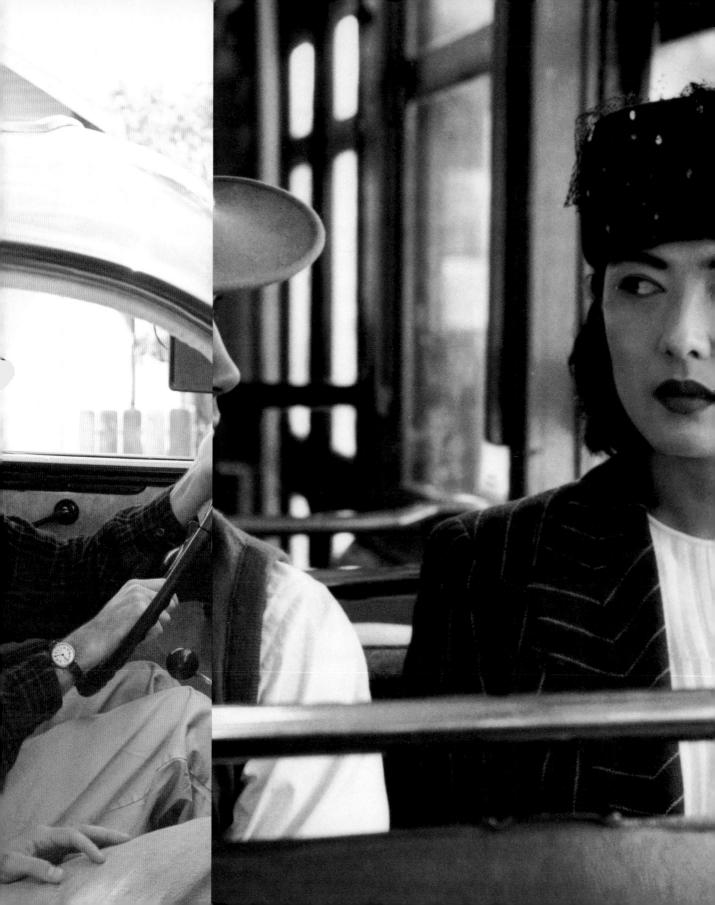

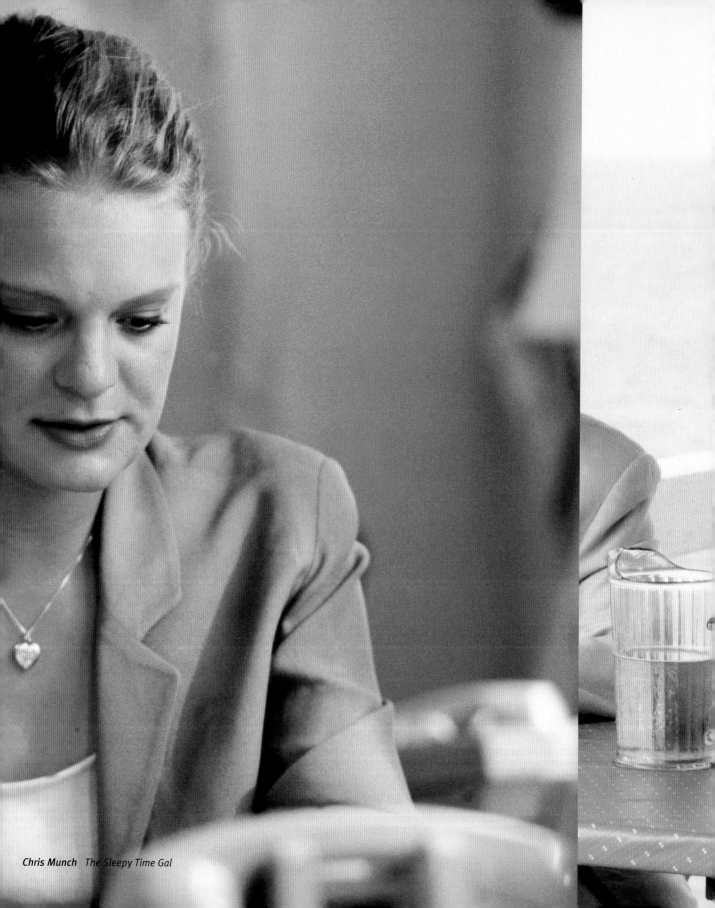

Chris Munch *The Sleepy Time Gal*

The Sleepy Time Gal

ARTSPACE IS online

http://www.bohemiamag.com/page8.html

http://www.bohemiamag.com/page9.html

ARTSPACE IS ABOUT ideas

1986

Paintings of Emotion – Fifteen Paintings from Berlin
Andreas Weishaupt, Elvira Bach, Salomé, Rainer Fetting, Markus Lupertz,
Thomas Schindler, Peter Chevalier
February 25 – April 5, 1986

Three Color Photographers
Bill Sanders, Marion Bulin, Petra Davis Storey
May 20 – July 3, 1986

Fictional L.A.
Dan McCleary, Roland Reiss, Steve Rogers
July 17 – August 16, 1986

Paravent
David Bates, Deborah Oropallo, Robert Mapplethorpe,
Markus Lupertz, Roy De Forest, Salomé, Irene Pijoan, Robert Dix,
Elvira Bach, Ed Ruscha
September 16 – October 25, 1986

Izhar Patkin: The Black Paintings
November 13 – December 21, 1986

1987

Portrait/Self-Portrait
Robert Arneson, John Bloom, George Condo, John Davies, Barbara Friedman,
Joan Logue, Markus Lupertz, John Mandel, Mimmo Paladino, A.R. Penck,
Irene Pijoan, Chuck Walker
January 13 – February 21, 1987

Poignant Sources
Collaborative Paintings by Luciano Castelli, Rainer Fetting, Salomé
Photographs of the Berlin Wall by Leland Rice, John Gossage, Michael Schmidt
Video by Marcel Odenbach, Klaus Vom Bruch, Ulrike Rosenbach
March 10 – April 18, 1987

Jenny Holzer: Signs
May 5 – June 27, 1987

1987 Grant for an Individual Artist: Sculpture Award Exhibition
Major Award Recipient: Tony Labat
July 14 – August 15, 1987

Patrick Ireland: Morton's Journey
A New Installation
September 15 – October 24, 1987

Out of Eastern Europe: Private Photography
Organized by the MIT Committee on Visual Art
and curated by John P. Jacob
November 10 – December 19, 1987

1988

**General Idea: The Public and Private Domains
of The Miss General Idea Pavillion**
January 12 – March 5, 1988

Wayne Zebzda: RIPOFF: On the Nature of Security
Sculptural Installation
March 22 – April 30, 1988

Memory and Vision: Astrid Klein and Katharina Sieverding
May 17 – June 25, 1988

1988 Grant for an Individual Artist: Painting Award Exhibition
Major Award Recipient: Darryl Sapien
July 12 – August 13, 1988

The Lion Rampant: New Work from Scotland
Ken Currie, Ian Hughes, Keith McIntyre, David Hosie, Ron O'Donnell,
Eddie Summerton, Pictorial Heroes (Doug Aubrey and Alan Robertson)
September 13 – October 22, 1988

Santuarios: A Chapel by Michael Tracy
November 8 – December 17, 1988

1989

David Mach: Stream of Consciousness
Installation
January 17 – February 25, 1989

Jo Babcock: Low Tech
Pinhole Cameras and Photographs
March 14 – April 22, 1989

FRAMED
From A Troubled Land: Photographs by Paul Graham
I a Wo/MAN: The FBI File on Andy Warhol
Installation by Margia Kramer
Curated by Lynn Gumpert
May 9 – June 17, 1989

1989 Grant for an Individual Artist: Sculpture Award Exhibition
Major Award Recipient: Mark Pauline
July 11 – August 19, 1989

A Circuit of Style: An Installation by Lisa Hein
September 26 – November 18, 1989

Artists' Toy Factory
December 12 – 17, 1989

1990

Matt Heckert: A Mechanical Sound Orchestra
January 23, 1990 – March 10, 1990

Michael Tracy: Mirror of Justice/House of Gold
May 1 – June 9, 1990

1990 Grant for an Individual Artist: Painting Award Exhibition
Major Award Recipient: Deborah Oropallo
June 19 – August 4, 1990

The Idealists at the Raab Galerie, West Berlin
Curated by Anne MacDonald, San Francisco Artspace
Stefan Kürten, Matias Jaramillo, Tony Labat
July 20 – August 30, 1990

Einstürzende Neubauten: Ten Years
November 15 – December 8, 1990

Artists' Toy Factory
December 18 – December 23, 1990

1991

Bobby Neel Adams: Age Maps/Couples
February 14 – March 16, 1991

Marshall Selby Weber: TV Tumor
April 18 & 19, 1991

LocoMotion, Animation installations
Robert Dix, Matias Jaramillo, Isabella Kirkland, Tony Labat
May 14 – June 22, 1991

Erotic Drawings
Gonzalo Hidalgo, Barney Haynes, David Ireland, Matias Jaramillo, Isabella Kirkland, Stefan Kürten, Paul Kos, Tony Labat, Tom Marioni, Deborah Oropallo, Irene Pijoan, Maria Porges, Rex Ray, Ted Stevens, Wayne Zebzda
September 17 – October 31, 1991

The Brain Brothers: Cliches
November 12 – December 7, 1991

Artists' Toy Factory
December 14 – 22, 1991

1992

Eduardo Michaelsen: Painting Exhibition
January 21 – February 29, 1992

Videos from the Whitney Biennial
March – April 1992

Video Grant Recipients' Premier Screening
Tony Ramos, Valerie Soe, Michelle Handelman
September 15, 1992

Maria Fernanda Cardoso: Calabazas
September 22 – October 31 1992

Ella Tideman and Cliff Hengst: PSSSST!
November 10, 17, 24 and December 1, 1992

Sophie Calle and Greg Shepard: Double Blind
November, 1992

Artists' Toy Factory
Organized by Wayne Zebzda and Matias Jaramillo
December 11, 12 and 13, 1992

1993

Nayland Blake: Philosopher's Suite
January 12 – February 20, 1993

Stefan Kürten: Life Cycles
March 9 – April 24, 1993

**ARTSPACE ANNEX 1989-1991
EXHIBITION SCHEDULE**

1989

The New Narratology: Examining the Narrative in Image/Text Art
Jack Balas, Nayland Blake, Margaret Crane and Jon Winet, Mark Durant, James Morris
Curated by Maria Porges
March 14 – April 22, 1989

1989 Grant For An Individual Artist: Sculpture Award Exhibition
Support Grant Recipients: Mark Paschall, Alan Rath
July 11 – August 19, 1989

Vena Cava: An Installation by Irene Pijoan
Thesis/Antithesis: A Mixed Media Installation by Enrique Chagoya
September 26 – November 11, 1989

An Instinct for Happiness
Three weeks of artists' projects: Matias Jaramillo, Wayne Zebzda, The Brain Brothers
November 28 – December 14, 1989

1990

Barney Haynes: An Installation
January 23 – March 11, 1990

Vittorio Scarpati
January 23 – March 11, 1990

Corners
Paul Kos' SFAI Graduate Students
March 20 – April 7, 1990

George Kuchar/Tony Labat
Leona Helmsley/James Brown Exhibition
April 17 – June 2, 1990

1990 Grant Award for an Individual Artist: Painting Award Exhibition
Support Grant Recipients: David Cannon Dashiell, Rick Arnitz
June 19 – August 4, 1990

Jessica Diamond: Food for Thought
Curated by Dan Cameron
September 11 – October 27, 1990

Matias Jaramillo: Highway to Heaven
Stefan Kürten: Pictures from this Life
November 13 – December 15, 1990

1991

Soft As Wax: Video, Performance and Music
September 27, 1991

**SAN FRANCISCO ARTSPACE
PERFORMANCES**

1989

Endurance Actions
An evening of artists' actions on the theme of endurance.
Participating artists include: Ramon Churruca, quanTA LA gusTA, Shelley Cook, Bernadette Cotter, Barney Haynes, Gonzalo Hidalgo, Matias Jaramillo, Tony Labat, Hugh Pocock
January 20, 1989

Wayne Doba: A Something Project
Harvey Stein: Their Big Talking Guns
Harvey Stein premiered a multi-media monologue on the history of the West, *Their Big Talking Guns*, at the Artspace Annex
January 27 and 28, 1989

New Narratology
Readings/Performances by artists Nayland Blake, Mark Durant, Margaret Crane/Jon Winet, James Morris
March 14 – April 22, 1989

The Information Place
Screening of *Terror of Mechagodzilla, Godzilla vs Mothra, La Dolce Vita,* and other movies and the 5 o'clock news
May 17 – May 20, 1989

1990

The Theory of Total Blame
A play by Karen Finley presented in association with
Theatre Artaud, 450 Florida Street
February 28 – March 3, 1990

Matt Heckert: Performances of Mechanical Sound Orchestra
on Thursdays, February 1 – March 8, 1990

1991

TV Tumor
A collaborative video/performance piece by Marshall Selby Weber
and Phillip Patiris
April 18 and 19, 1991

SAN FRANCISCO ARTSPACE LECTURE PROGRAMS

Ingrid Raab, director of Raab Galerie, Berlin, lectured in conjunction with the exhibition **Paintings of Emotion – Fifteen Paintings from Berlin.** May 1, 1986

Salomé, Berlin artist participating in the exhibition **Poignant Sources**, discussed his work. March 12, 1987

Jenny Holzer discussed public art in New York City in conjunction with her exhibition **Signs**. May 28, 1987

A public conversation with 1987 Sculpture Grant Recipient **Tony Labat** and writer **Carlo McCormick**. August 4, 1987

Critic-in-residence **Gary Indiana** presented a public reading of his fiction work. September 17, 1987

Writer and critic **Brian O'Doherty** spoke on "Orson Welles: Kane/Arkadin." October 22, 1987

Artist **Patrick Ireland** discussed his work and his Artspace exhibition in the context of "Installations: Temporary Art in The Future of Memory." October 23, 1987

Guest curator **John Jacob** presented a walk-through discussion of the exhibition **Out of Eastern Europe: Private Photography**, Nov. 11, 1987. The exhibition also featured evening programs of Eastern European video and performance artists presenting videos and performance documentation from their native countries. On November 18, **Tomasz Sikorski** presented and discussed video art from Poland; December 2, **Miha Vipotnik** presented Yugoslavian videos; and on December 9, **George Pinter** and **Gabor Lukin** presented Hungarian videos.

General Idea artists spoke on "Museum as Found Format," in conjunction with their Artspace exhibition. January 13, 1988

Lecture by critic-in-residence **Bruce Ferguson**, titled "Abstraction in Question," on artists working outside of traditional art formats and on the issues and aesthetics of time-based work. February 17, 1988

Wayne Zebzda presented a public discussion of his work in conjunction with his exhibition **Ripoff: On the Nature of Security**. March 14, 1988
Public lecture by the 1987 Artspace Painting Grant Recipient **Darryl Sapien** on his work. July 14, 1988

In conjunction with the exhibition **The Lion Rampant: New Work from Scotland**, participating artists **Ken Currie** and **Ron O'Donnell** offered a public lecture. September 14, 1988

Gallery talk by **Michael Tracy** on his work and the installation **Santuarios**. November 9, 1988

Jo Babcock presented a public discussion of his work, pinhole cameras, and the exhibit **Low Tech**. March 16, 1989

Lisa Hein, **Irene Pijoan**, and **Enrique Chagoya** gave a gallery talk. October 5, 1989.

Deborah Oropallo, **Rick Arnitz**, and **David Cannon Dashiell** gave a gallery talk. June 26, 1990

FILM SUPPORT

Color of a Brisk and Leaping Day, director Chris Munch.

The Sleepy Time Gal, director Chris Munch.

SAN FRANCISCO ARTSPACE VIDEO PROGRAMS

Daily screening of videotape by **Joan Logue**, *New England Fisherman: Spots* (1985), as part of the exhibition **Portrait/Self-Portrait.** January 13 – February 21, 1987

In conjunction with the exhibition **Poignant Sources**, daily screening of the following videotapes: *I'm Taking the Pain Test* (1984), by **Marcel Odenbach**, *The Allies' Tape* (1982), by **Klaus von Bruch**, and *Don't Think I'm an Amazon* (1975) by Ulrike Rosenbach. Also presented was the videotape *The Bitch and Her Dog* (1981) documenting a street performance by **Luciano Castelli** and **Salomé**, artists featured in the exhibition. March 10 – April 18, 1987

As part of the exhibition by 1987 Artspace Sculpture Grant Recipient **Tony Labat**, six videotapes by the artist were shown: *Babalu* (1980), *Room Service* (1980), *N* (1982), *Kikiriki* (1983), *Lost in the Translation* (1984), *La Jungla* (1985), and *Mayami: Between Cut and Action* (1986). July 14 – June 27, 1987

Daily and evening screenings of *State of the Art*, a six-part documentary series addressing issues in contemporary art, through interviews with artists, critics, collectors and dealers. Produced by **Illuminations** for Channel 4, London, and WDR, Cologne. Segments were titled: *1.History 2.Value 3.Imagination 4.Sexuality 5.Politics 6.Identity* September 15 – October 24, 1987

In conjunction with **Out of Eastern Europe: Private Photography**, Artspace presented daily screenings of vidotapes by Eastern European artists living in exile in the United States. These included: *Pale of Night* (1986), by **Ante Bozanich**, *Killer* (1986) and *Luck Smith* (1987), by **Gustav Hamos**, and *Questions to Another Nation* (1985), and *Love Among Machines* (1986), by **Miroslaw Rogala**. Also presented were evening screenings of artists' videotapes from Poland, Yugoslavia, and Hungary. November 10 – December 19, 1987

Daily screenings of three videotapes by **General Idea** in conjunction with their Artspace exhibition. Included were: *Test Tube* (1979), *Cornucopia* (1982), and *Shut the Fuck Up* (1985). January 12 – March 5, 1988

Daily screenings of videotapes documenting the work of **Wayne Zebzda**, in conjunction with his exhibition. March 22 – April 30, 1988

Daily screenings of videotapes documenting performance works by **Darryl Sapien**. July 12 – August 13, 1988

During the exhibition **The Lion Rampant: New Work From Scotland**, Artspace held daily screenings of videotapes by **Pictorial Heroes (Doug Aubrey and Alan Robertson)**, and a compilation of tapes produced at the Artist Television Workshop, Duncan of Jordanstone College of Art, Dundee. September 13 – October 21, 1988

World premiere video event: **Tony Labat's** *An Excuse For Dialog*. Screening of Labat's *A Jar Full of Jam* (1988) and *True Love* (1988), and an installation of *The Fisher Price Project* (1988), a collaborative work by Labat and students from the San Francisco Art Institute. November, 1988

Weekly Video Screenings
Open screenings of videotapes submitted to Artspace during the previous week. Interested artists were encouraged to submit tapes to Artspace on an on-going basis for review by a selection committee. The selection committee was composed of **Kathy Brew**, **Tony Labat**, and **Mark Durant**. January 21, 28, 1989 (and every Saturday throughout the year)

VIDEOGRAPHY

Mao Meets Muddy directed by Tony Ramos, 1991

Mutt directed by Tony Labat, 1991

Toxic/Detox directed by Tony Oursler and Joe Gibbons, 1992

The History of Pain directed by Michelle Handelman, 1992
Athens Film & Video Festival, San Francisco Cinematheque, Den Haag Holland, Chicago Film Festival

Einstüerzende Neubauten, 1992
Double-Blind directed by Sophie Calle & Greg Shepard, 1993
Whitney Biennial '93, N.Y. Film festival '94, Telluride Film Festival '94, Lisbon Film Festival '95

Shooting-Script directed by Lynn Hershmann, 1993
Mill Valley Film Festival '93

Beyond and Back directed by Anne MacDonald, 1993

Philosophers' Suite directed by Nayland Blake, 1994

Artists in the Kitchen directed by Anne MacDonald, 1994

Making-Waves (San Francisco Music Day), 1994

Just Desserts directed by Anne MacDonald, 1995

Here directed by Stefan Kürten, 1996

Lunch Movies directed by Jim Elliott, 1997–2000

ARTSPACE BOOKS

Memories That Smell Like Gasoline
By David Wojnarowicz

Jerk
Art by Nayland Blake
Fiction by Dennis Cooper

Real Gone
Art by Jack Pierson
Fiction by Jim Lewis

Desire By Numbers
Art by Nan Goldin
Fiction by Klaus Kertess

The Strange Case of T.L.
Art by Tony Labat
Text by Carlo McCormick

Appendix A:
By A.M. Homes

Friendly Cannibals
Art by Enrique Chagoya
Text by Guillermo Gomez-Peña

The Fae Richards Photo Archive
Photographer Zoe Leonard
Filmmaker Cheryl Dunye

Hover
Photographs by Gregory Crewdson
Text by
Rick Moody
Darcey Steinke
Joyce Carol Oates
Bradford Morrow

Stardumb
Art by John deFazio
Stories by Dave Hickey

ARTSPACE MAGAZINES

Shift 1 – Shift 17, 1988–1993

Bohemia Magazine online publication, www.bohemiamag.com

EDITED BY ANNE MacDONALD

BOOK AND COVER DESIGN BY KRISTIN JOHNSON

DESIGN ASSOCIATE KIM MALEY

COPY EDITED BY MAUREEN KEEFE

SPECIAL THANKS TO ED LEFFINGWELL

ISBN: 1-891273-02-7

PRINTED IN HONG KONG

ARTSPACE BOOKS ARE AVAILABLE TO BOOKSTORES THROUGH OUR PRIMARY DISTRIBUTOR:
D.A.P./DISTRIBUTED ART PUBLISHERS, 155 SIXTH AVENUE, NEW YORK, NY 10013
TEL: 212-627-1999 OR 800-338-BOOK

ARTSPACE BOOKS ARE PUBLISHED BY ARTSPACE, 62 WHITE STREET, NEW YORK, NEW YORK 10013
TEL: 212-431-0498 FAX: 212-431-8364 E-MAIL: ARTSPACE62WHITE@AOL.COM

VISIT US AT WWW.ARTSPACE-SF.COM